Starting with Sculpture

Cover photograph Figure 1952 by R. Dawson, terracotta

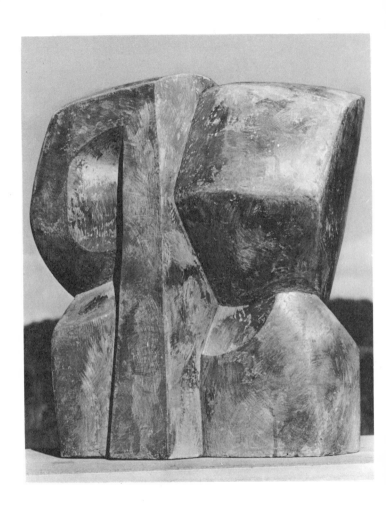

Homage to Julian Grimau by R. Dawson, cast aluminium

Starting with Sculpture

the elements of modelling and casting

Robert Dawson

Studio Vista London
Watson-Guptill Publications New York

Acknowledgments

The author and publishers would like to make the following acknowledgments for illustrations in this book:

Figs. 1, 2, 32, 44, 55 by courtesy of the Trustees of the British Museum, London
Figs. 56–7 Castrol Ltd, Castrol House, London
Page 2, Fig. 18 Mary Farnell
Figs. 14, 34, 56, 65 Bill Jordan
Fig. 48 Mansell Collection
Figs. 103–110 James Mathieson
Fig. 52 Professor Mogens Bøggild, Copenhagen
Figs. 66–8 Fred Morgan
Fig. 49 Ministry of Information, Federation of Nigeria, Lagos
Figs. 31, 45 Tate Gallery, London
Remainder by Jim Butler ARA, Mike Srawley and the author.

Some of the material used in the section on modelling in terracotta, armatures, casting in plaster and casting in concrete was first published in *Amateur Artist*

The author thanks Mike Srawley and Jim Butler ARA for the technical photographs as well as several others, and his wife for the typing

General editors: Brenda Herbert and Janey O'Riordan
© Robert Dawson 1968
Published in London by Studio Vista Limited
Blue Star House, Highgate Hill, London N19
and in New York by Watson-Guptill Publications
165 West 46th Street, New York 10036
Distributed in Canada by General Publishing Co. Ltd
30 Lesmill Road, Don Mills, Toronto, Ontario
Library of Congress Catalog Card Number 68-26318
Set in Univers 8 and 9 pt
by V. Siviter Smith and Co. Ltd, Birmingham
Printed in the Netherlands
by N. V. Grafische Industrie Haarlem
SB 289.37067.1

Contents

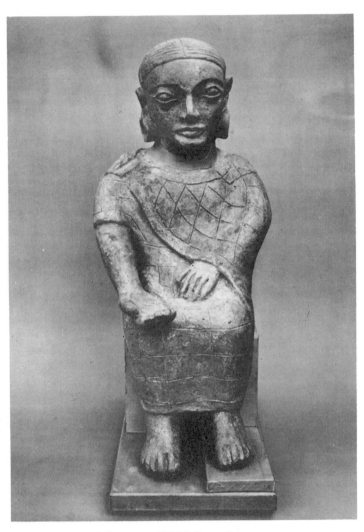

Fig. 1 Female portrait, Etruscan, *c.*600 BC. Terracotta

Introduction

Since time immemorial, man has been concerned with making representations of himself and the things around him. At the time that he was painting superb pictures of hunted animals on the walls of caves in southern Europe, Aurignacian man was modelling the same animals in clay, carving pieces of bone, and producing human figures in clay and stone.

Much sculpture has been symbolic, but mankind has also felt the need for decoration and ornament, and it is difficult to find a society where, in one form or another, the results of this urge are not apparent.

It would be interesting to discuss the origins of art and the psychology of the need to produce it, but it is outside the scope of this book; sufficient to say that it exists as much today as ever it did among our early ancestors.

This book deals with sculpture in plastic materials and casting techniques, since this is probably of most interest to the beginner. It leaves out casting in metals, carving, and the techniques for welding and making constructions, which will be the subject of a later volume in the series.

My aim has been to produce a manual of instruction that will enable the beginner to produce sculptures by simple means, without further technical instruction. The book will carry him through more complex and sophisticated techniques to the point where he will require specialist information.

Using the book

Because of the wideness of the subject and the amount of material dealt with, a great deal of compression has been necessary.

It is assumed that the student will start at the beginning and read through the book at least once. Each subject follows its predecessor logically. I have started with the simplest methods so far as it is possible, and have dealt with complications of these subsequently. It will often be necessary to refer back to a previous section. For example, when the technique of casting in concrete is described, it is necessary to go back to Modelling in Plaster for information on mixing plaster and to Casting in Plaster for making a plaster mould.

This cross referencing has been made as clear and as simple as possible.

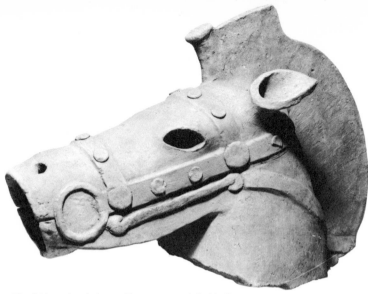

Fig. 2 Horse head, Japan. Terracotta, modelled hollow

In the main, techniques have been described in relation to the human figure, because this is often the starting point in learning sculpture; but the methods can easily be adapted to other forms.

The illustrations may be divided into two groups: a series of drawings and photographs are used with the text to explain methods and are numbered to cross-refer to the text. As far as possible, corresponding text and illustrations are adjacent, and only occasionally will it be necessary to turn a page to examine the appropriate illustration.

The second group of illustrations are examples, both historical and contemporary, which not only demonstrate the subject under discussion, but are considered to be superb examples of their kind. I am sure that the reader will come to revere at least some of these sculptures as much as I do myself.

Understanding and mastering a technique will not make a sculptor. Without doing so, however, it is impossible to be a sculptor. Despite the selection of examples, this book is about methods rather than ideas, and I have discussed aesthetics only in so far as they impinge on technique. It leaves the onus on the student to study the works of the masters of the past and contemporary artists; for in the end this is the only way to become a sculptor.

Clay

Clay is the most widely used material for modelling because it is plentiful, cheap, and adaptable. Traditionally, sculptures made in clay have been sun-dried, if intended only as temporary works, or fired, as is done with pottery, to make them more permanent. With the development of casting techniques, it has become the chief medium for sculptures where the intention is to transpose them into another material.

Clay consists of the oxides of silicon and aluminium, i.e. silica and alumina, which make up a large part of the earth's bulk. In clay these oxides form a compound which takes up water. Clay also often contains free water and free silica in the form of sand, and iron compounds.

Anyone who has picked his way through a gateway trampled by cows in rainy weather will have a fair idea of the nature of clay: when wet it is extremely sticky. The same gateway in summer, however, after a spell of dry weather, will be hard, and ridged with the imprint of animals' feet.

Fig. 3 A group of sketch models

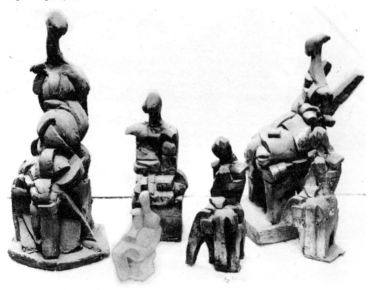

This is not pure clay of course, but loam. The more clay it contains, the stickier it will be in winter and the harder in summer. So we see that wet clay is sticky and soft and dry clay is hard. These are the qualities that make it useful to the sculptor.

Usually a sculptor orders clay from a merchant who supplies sculptors' or potters' materials (see List of suppliers p. 103).

White pottery clay This clay is white only when fired. When wet and fit for use, it is a light grey in colour. It is rather smooth and soapy in texture. It may be coarsened by the addition of sand or grog (powdered terracotta).

Red pottery clay Similar to white clay, but its higher iron oxide content gives it the characteristic red colour. When wet, the clay is anything from an orange-brown to a dark chocolate-brown. When fired, it assumes the characteristic light red colour.

Terracotta clay This is red clay that has had sand and/or grog added to it. All the above clays may be obtained from the merchant ready for use, wrapped in polythene (polyethylene) in half-hundredweight (56 lb.) or hundredweight (112 lb.) batches.

Storage

Clay may be stored and re-used indefinitely. In fact, the more it is used the better it becomes.

The simplest place to store it is in a lidded polythene (polyethylene), galvanised or enamel bucket, with a sheet of clear plastic tucked over the top of the clay to keep it moist — for larger quantities a galvanised or plastic dustbin (garbage can) is ideal. A large bucket will hold half a hundredweight (56 lbs.). It is as well to have a second bucket in which to store clay that has become too dry and hard to work and needs reconstituting.

Maintenance

When clay is bought from the merchant, it is usually in good working condition. If it has become too firm in transit, put it in the bucket with a wet sack over it and cover with clear plastic. Moisten the sacking as necessary, and within two or three days the clay should be in good working condition—soft enough to be pliable and capable of sticking together, but not sticky.

Preparation, rough mixing

Clay that has become too hard to work with should be moistened as described above. It will, however, tend to be a mixture of sticky clay and hard lumps and must be brought to an even consistency.

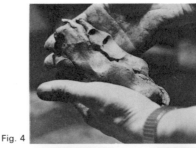

1 Take a large handful and press into a sausage shape (Fig. 4).

Fig. 4

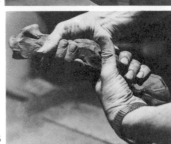

2 Squeeze until it doubles in length (Fig. 5).

Fig. 5

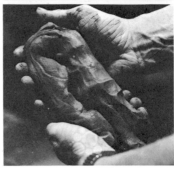

3 Double the clay over and repeat the process (Fig. 6).

Fig. 6

Wedging

If it is proposed to fire the clay, it is necessary to prepare it more thoroughly, firstly to ensure that it is even in texture throughout, and secondly to exclude air bubbles (see p. 16 on terracotta modelling). The process is known as wedging.

Clay will stick to a non-absorbent surface, therefore a varnished, metal, or plastic surface is useless for wedging. Untreated wood, cement or Plaster of Paris will make a good surface.

1 Take a suitable quantity of clay and pat it into a ball. A very large or very small quantity is difficult to wedge (Fig. 7). Fig. 7

2 Lay the hands on it, thumbs together (Fig. 8). Fig. 8

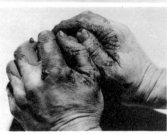

3 Roll it back towards you so that the hands are at right angles to the wrists; do not dig the fingers into the clay (Fig. 9). Fig. 9

4 Keeping the hands in this position, press forward so that the balls of the hands make two hollows in the clay. Do not let the hands roll back to the former position. The clay will now have the shape of the head of a bull (Fig. 10).

Fig. 10

5 Replace hands on clay as in 2 (Fig. 8) and roll it back towards you (taking care, as before, not to dig the fingers into the clay), dropping the wrists as in 3 (Fig. 9). This action will press the upper part of the clay into the lower. Place the hands in position for the next push (Fig. 11).

Fig. 11

6 Push forward again as in 4 (Fig. 10) and repeat the process (Fig. 12).

Fig. 12

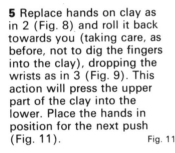

7 The 'horns' of the 'bull' will tend to get longer as the process is repeated. When too long, turn them in, slap them down with the palm of the hand.
Turn the mass of clay on its side and continue until the clay is of a smooth, even consistency (Fig. 13).

Fig. 13

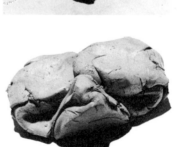

Preparing terracotta clay

If terracotta clay is not bought ready-prepared, either fine sand or grog (powdered terracotta) should be mixed with pottery clay. Up to one part grog or sand to two parts clay can be mixed. The effect is to make the clay more open (allowing air to escape during firing), decrease shrinkage, which may be as much as one tenth during drying and firing, and make shrinkage more even.

The clay should be fairly wet and the grog or sand should be damp (but not wet). Mix thoroughly as described in Rough Mixing (p. 11), and then wedge (p. 12).

Preparing dry clay

Sometimes it will be necessary to prepare dry clay for modelling, and indeed it is easier to prepare large quantities of clay when it is bone dry than when it is moist but too hard to work.

1 Break up the lumps of clay with a hammer into small pieces.

2 Put them in a bowl or other suitable container (preferably not too deep) and sprinkle them with water.

3 Cover with wet sacking.

4 Continue to moisten as necessary; avoid flooding the clay.

5 After a day or two (or less if the quantity is small), beat the clay down with a mallet or similar piece of wood. The clay at the bôttom will tend to be wetter than that at the top, but if the water has been applied with care it will not be very sticky.

6 Prepare the clay as described above.

7 Transfer prepared clay to the storage bin.

Some experiments to discover the nature of clay

If clay is too wet, it will be sticky. It will not hold its shape and will be very difficult to manipulate.

If it is too dry, it will tend to lose its elasticity and develop small cracks. It will not adhere well to another piece of clay.

Before starting modelling, discover the nature of the clay. A few hours spent experimenting will give a good basis for future work and will obviate mistakes which can be costly in wasted effort.

The following experiments are suggested:

1 Take a piece of clay approximately 1″ in diameter. It should be soft but not sticky. Roll it in the hands, pinch it flat, double it over, roll it into a ball. After a few minutes it will become too dry to work and will develop little cracks. See how much handling the clay will stand before it becomes unworkable.

2 Slap a piece of clay into a sausage shape and roll it on the table so that it becomes a long, even cylinder $\frac{1}{2}$″ in diameter. It will take quite a lot of practice to keep it cylindrical. Note that after a while little cracks will appear on the surface and, if you bend it, it will break in two. Clearly the clay has lost moisture and has become drier. This is due to both the warmth of the hands and absorption of water into the table. Note what is the most suitable condition of the clay for working.

3 Pinch up some simple little figures. Try various methods of joining pieces of clay together. Find out which are strong and which are weak. Roll out some thin pieces (e.g. for arms) and join them to a body. See if they will support their own weight and not sag.

Let the clay figures dry and note which parts are the most fragile.

Observations Handling clay makes it dry.

Placing clay on an absorbent surface dries it out.

Exposing clay to warm air makes it dry out.

Clay that has become too dry loses its malleability and tends to crack.

Clay that is too dry will not join easily.

Unless the clay is very moist, merely stubbing one piece on to another is not an adequate method of joining; the two pieces will separate while drying or firing.

Thin elements in a figure, while quite strong when the clay is damp, become extremely fragile when the clay dries out.

Precautions Only work with clay of the right consistency.

Keep the clay you are using under a damp cloth or wrapped in a clear plastic sheet.

Make sure joins are adequate to stand the strain of the drying process.

Design with the dry state in mind.

Terracotta

This is the technique whereby a sculpture is built in clay and fired in a kiln.

When clay is raised in temperature to approximately 650° F. (310° C.), the water is driven off in a chemical sense (as opposed to the mere drying out of clay at normal temperature) and the clay changes its nature.

It is no longer a dry, brittle material that can be reconstituted by the addition of more water, but is now a hard, permanent material that can break or chip, but can never be returned into malleable clay.

As pottery, it is known as *Biscuit* or *Bisque* — as sculpture it is *Terracotta*.

Advantages and disadvantages of the method Terracotta modelling has the major advantage that there is no casting process involved. The sculpture is modelled in clay which is then fired to complete the process.

The major practical limitation of the process is that it is necessary to have facilities for firing.

A kiln is a relatively bulky and expensive piece of equipment. It is a primary requirement for a potter, but less so for a sculptor, who usually works in a variety of media.

If it is proposed to make large numbers of terracotta sculptures, it may be worth buying a kiln. It is possible to build your own kiln, and information may be obtained from pottery journals.

Many places are within reach of a studio pottery (or even a commercial pottery) which will fire terracotta if the proprietor is convinced that the sculpture is soundly made and is no danger to the pots he is firing.

Most Evening Institutes in Great Britain and adult education centres in America have classes in pottery and modelling. It may be worth joining one for instruction and facilities. Assuming firing facilities are available, there are a number of considerations.

If air is trapped in a sculpture that is to be fired, it will expand during the firing and the pressure built up may crack or break the sculpture. Sometimes thick sculptures actually explode in the kiln. A thick mass of clay dries out less well and, during firing, the outside heats up and shrinks before the inside, causing undue stress. If any part of the sculpture is too thick, it must be hollowed.

Because clay shrinks when it dries and is fired, but an armature

remains the same size, it is not possible to build the sculpture on an armature unless it can be removed before drying. This limitation is the key to terracotta sculpture and demands careful planning before work begins.

The size of a sculpture depends on the size of the kiln available for firing it. Always make sure of this when designing a terracotta.

The larger the sculpture, the more difficult it is to handle at the dry-clay stage, when it looks strong but is in fact extremely brittle and liable to damage.

(I am reminded of the principal of an Evening Institute who swept into the pottery class with a visitor, saw a large jug on the bench and with an 'Oh, Mr Smith, what a delightful jug!' lifted it up by the handle; only the handle rose with her hand, the rest remained on the bench.)

Because of the fragility of the dry clay, it is wise to design the sculpture as compactly as possible. Taking a human figure as an example, extended arms or arms joined only at the shoulders are very fragile. A figure supported by two thin legs is adequate in a human being, but very unsafe in dry clay. Once the figure is fired, it is much stronger: most catastrophes occur at the dry-clay stage.

There is no hard and fast line between sculpture and pottery. The potter tends to think in somewhat different terms from the sculptor—the approach to building a work is different. But the tools and materials may well be the same.

Sculptures may be glazed or left as terracotta. I shall not describe techniques for glazing; nor applied, pressed, and incised ornament; nor figures made up of an assemblage of clay parts. These are typically pottery techniques and are dealt with in books on the subject.

The clay

Terracotta clay, as already stated, should be of open texture. This permits air to seep out through the surface during firing.

Red or buff clay is usually used because, when fired, it has a pleasant colour.

White clay looks cold and dead when fired and should not be used unless it is intended either to glaze or paint the sculpture.

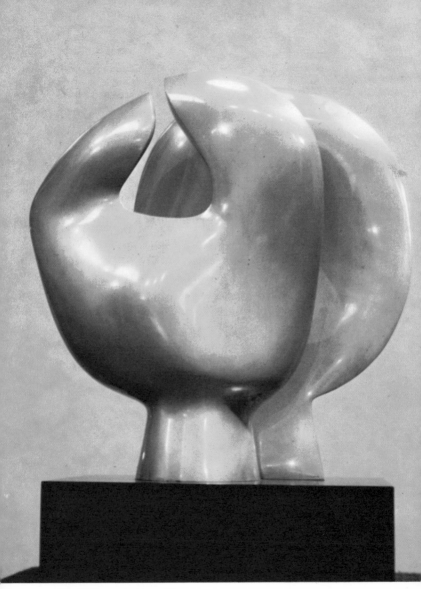

Fig. 14 Bronze by Henry Moore

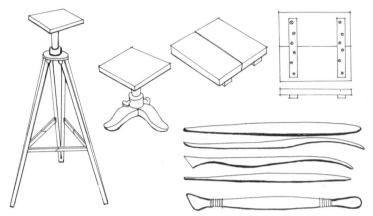

Fig. 15 Modelling stands, modelling board, wooden modelling tools, wire modelling tool

Preparation of terracotta clay

The clay should be of a suitable type and well wedged (see p. 12) to ensure an even consistency and absence of air bubbles.

Material: Modelling clay.

Equipment: Shaped boxwood modelling tools.
Wire-ended tools (loop of wire on handle). Improvised tools—nail file, kitchen knife, etc. Simple handyman tools and equipment to be obtained as and when needed—hammer, screwdriver, pliers, handsaw, carpenter's square, bradawl (awl) or carpenter's brace or hand drill, screws.

Modelling board: Wooden board on which to work. It should be an inch or more in thickness. It can easily be made from standard 6″ × 1″ floorboard (e.g. two lengths of board 12″ × 6″ × 1″ held with two strips 11″ × 1½″ × 1″ screwed ·underneath). Boards may be bought from artists' suppliers, but avoid those made of beech, which warp excessively and are very hard

if anything has to be screwed or nailed to them. Do not use plywood. Do not seal the surface.

Modelling stand: Stand with a revolving top, ranging from small table models to heavy stands with geared height adjustment. Not essential but very useful.

Sketch models

Under The nature of clay on p. 15 is described the making of small pinched figures. Such figures are excellent for stimulating ideas. Any that are considered worth continuing may be developed until the major problems of the form have been solved.

Making a terracotta figure: method I

1 Make a core by squeezing a piece of clay into the approximate shape of the sculpture. Leave it to firm up (Fig. 16).

Fig. 16

2 Trim the core as necessary. Build the sculpture on it (Fig. 17).

Fig. 17

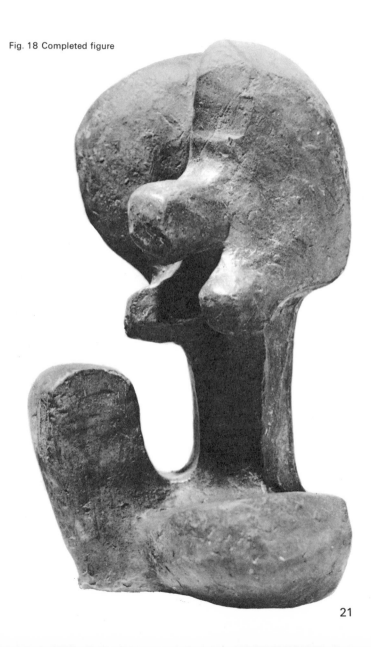

Fig. 18 Completed figure

Take care that air is not trapped in the clay. Adding clay by pressing pellets down firmly on to the underlying clay is the easiest way to avoid it.

Moisten the clay with a spray if it begins to get too dry. Wet clay will not adhere to dry.

If it has to be left for any length of time, the sculpture should be covered with a thin plastic sheet, preferably completely enveloped. Do not put a damp rag on the sculpture under the plastic unless the sculpture is too dry. If the atmosphere under the plastic becomes too humid, the clay will become sodden and the sculpture may disintegrate.

Wrap your spare clay in a damp rag or a piece of plastic sheet to stop it drying out.

With this method, an armature may be used provided that it can be removed during the hollowing process (see Portrait Heads p. 46).

3 Hollow the sculpture so that nowhere is too thick. Turn the sculpture on its side on a pad of rags or sacking and take care not to damage the modelled surface while digging out the inside.

Fig. 19

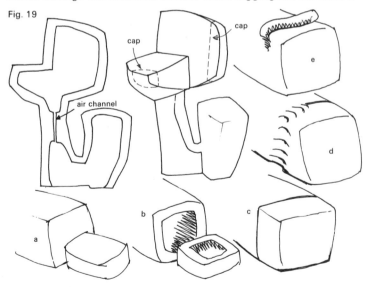

Do the hollowing while the sculpture is still leather-hard. If the sculpture is soft it will distort; if too hard it will be very difficult or impossible to hollow.

A large terracotta sculpture may be an inch thick but is normally from a quarter to half an inch, depending on the size and design.

If the sculpture is complicated, it may be necessary to cut out one or more caps, hollow out beneath them and replace them (Fig. 19).

(a) Cut the cap off with a thin wire or knife.

(b) Hollow out. A wire tool is useful for this operation.

(c) Wet the two surfaces and press them firmly together.

(d) Weld the join by dragging clay from one side to the other with a modelling tool. This will leave a groove round the join.

(e) Roll a thin sausage of clay, put it in the groove and rework the surface so that the groove disappears.

Ensure that the hollowed out part is connected to the outside, if necessary by an air channel, otherwise in effect an enormous air pocket is created which will probably cause the destruction of the sculpture during firing.

4 Dry out. If fired while damp, the sculpture will crack.

5 Fire. The temperature in the kiln should be raised slowly.

Making a terracotta figure: method 2

Building hollow with coils, i.e. ropes of clay.

This method should be used on simple shapes at first, although, with experience, much more complex forms may be developed.

1 Roll out a number of coils. Keep them round. Do not make them too thin ($\frac{3}{4}''$ diameter for a life-size head or similar) (Fig. 20). Cover them with damp cloth or clear plastic.

2 Bend a coil to the required shape and stub the ends together (Fig. 21).

Fig. 20 Fig. 21

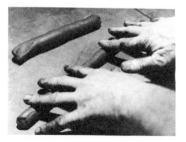

3 Place another coil on top of the first. Join by dragging clay with the thumb from the second to the first. Support the coils with the free hand while doing this (Fig. 22).

4 Incorporate a cross in the sculpture. Build it in as the coils are built. It both strengthens the sculpture and ties the sides in (Fig. 23).

Fig. 22 Fig. 23

5 Stop and allow to dry a bit and firm up before the weight becomes too great. Only build as much at a time as the clay underneath is capable of supporting.

6 Model on this hollow core. Large amounts of clay should not be added.

7 Dry out slowly (ensure that the air inside has an outlet).

8 Fire.

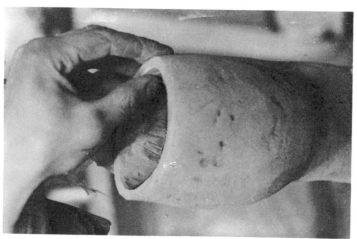

Fig. 24 Terracotta, coiling

Fig. 25 Interior of large terracotta showing struts and ridges in place of cross

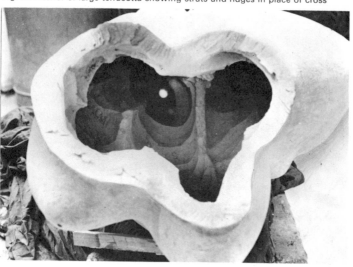

Modelling on an armature

The method used in sculpture governs the form, and the desired form governs the method.

If the concept includes attenuated form or slender forms supporting heavy ones, it is wise to use a frame or armature on which to build the sculpture.

Sculptures built in clay on an armature cannot be dried out and fired. The clay shrinks as it dries and, as the armature is stable, the clay will crack during drying or firing.

This means that a cast must be made of the sculpture. A mould is made, and from that a cast is produced either of plaster, concrete, or polyester resin (see casting p. 68). From the plaster cast, a foundry can make a replica in metal (bronze, aluminium, etc.), an expensive process, but one very widely used.

The sculpture may also be built in plasticine (plastilene) or direct in plaster, plastic resin, or concrete.

Preparation of clay

Clay similar to that used for terracotta may be used.

White clay (grey in the wet state) may be considered preferable as it shows up faults of form more readily and has not the charm of colour that terracotta clay has. Thus the danger of being seduced by the appearance of the clay, and disappointed by the unflattering quality of a plaster cast, is avoided.

The clay does not need the same amount of preparation as does that used for terracotta. It may be re-used *ad infinitum*, but should never be used for making terracottas and should be kept away from terracotta clay, as the impurities which this clay collects (fragments of plaster etc.) would cause damage to a terracotta sculpture. (See p. 11 for details of preparation.)

Sketch models

Work out the major forms by means of sketch models and drawings. When building a fixed armature (p. 33), a full-size front and side view is essential, and, if the group is at all complex, other views as well.

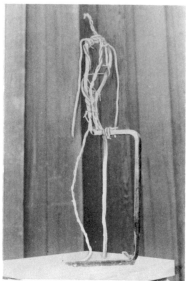

Figs. 26-27 An armature (rather untidy) of aluminium and galvanised wire on a support

Modelling a standing figure in clay using an armature support

Materials and equipment as for modelling in terracotta (see p. 19).

Also:

armature support (back iron), see 2, Fig. 28, a gallows-like metal to which the composition piping or aluminium wire that is going to be the core of the sculpture is tied. It should be sufficiently high that, when screwed on to the modelling board, it is at least halfway up the figure. It can be bought (either fixed or adjustable), or made of square mild steel.

composition piping:

cored lead pipe which can be bent readily and is used as a core for the trunk, arms, legs and head of a figure. Being flexible it requires a support.

27

or:

 square or round aluminium wire (heavy). For an 18″ figure,
 $\frac{1}{8}$″ or $\frac{3}{16}$″ is the right weight; for a 24″ figure, use $\frac{1}{4}$″ wire,
 used in the same way as composition piping. Much cheaper,
 slightly less rigid.
galvanised wire or thinner aluminium wire.
pliers.
wire cutters.

Making the armature

1 Decide on the size and form of the proposed figure.
2 Screw a suitable back iron on to the board so that the part to
which the armature is attached is as nearly over the centre of
the board as possible (Fig. 28).
3 Bend lengths of composition piping or aluminium wire to the
required shape for trunk, legs, arms, head.

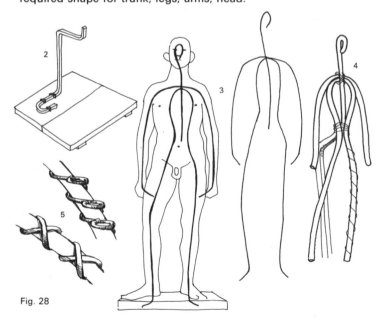

Fig. 28

The proportions of the armature are not the human proportions. Note that the neck is long and the arms well out, so that when the figure is built everything will be in its right place. Allow extra length in the legs, to include a clay base on which the figure will stand (Fig. 28).

4 Wire the parts firmly to the armature support at such a height that the figure will not be top-heavy, otherwise the armature may not be able to support the clay (Fig. 28).

5 Twist thin wire round the composition piping to act as a key to keep the clay from slipping off. If the figure is large, chicken wire may be wrapped round the trunk. Butterflies (small wooden crosses) to take the weight of the clay may be suspended where required (see Fig. 46 p. 47).

Work with your armature as near as possible at eye level. It is a mistake to work looking down on your sculpture.

Most sculptors build up a figure by applying the clay in small pieces; the closer they get to the final surface of the form, the smaller the pieces become. If the clay is put on in large bits, there is a tendency to lose track of the relationships of the different parts and the process can degenerate into haphazard cutting off and adding of clay in the hope that it will suddenly come right. It rarely does. Always work systematically.

Fig. 29 Face from the life-size figure, modelled and cast. Note simplified, understated features

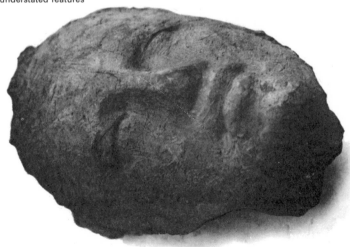

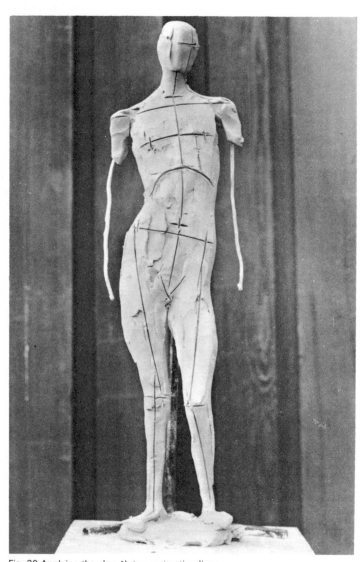

Fig. 30 Applying the clay. Note construction lines

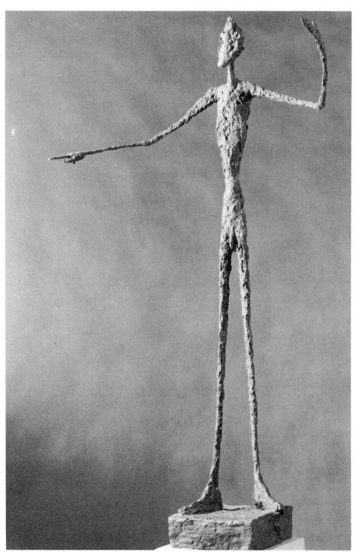

Fig. 31 *Man pointing* by Giacometti, bronze

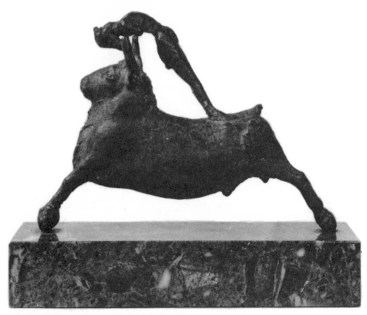

Fig. 32 Bull and dancer, Crete, *c.*1600 BC

1 Make the base and cover the whole armature with clay pressed firmly round it.
2 Mark the half and the centre line. As you build redraw these key lines. Lines should be filled in on completion of the figure (Fig. 30).
3 Develop the figure.

Do not pay attention to small elements such as eyes, mouth, fingers until the very end. They are of tremendous importance to us in human terms, but in sculptural terms should be subsidiary to the larger unity. Strongly emphasised features detract from this unity by drawing the observer's eye to the face, when the aim should be to let the eye play over the whole sculpture. Work on all sides equally—do not pay special attention to the front. Work all over the figure—do not let one part get much ahead of the rest.

Remember that you are going to have to cast the sculpture, so keep it simple and avoid delicate, fragile elements until you have experience in casting.

Making a fixed armature for a standing figure (Fig. 37)

This kind of armature is usually made of square mild steel, although for very small sculptures galvanised wire may be used.

Its advantage is that there is no back iron to get in the way and one can work on the sculpture from all sides without interference.

The disadvantage for a beginner is that an accurate full-size drawing of the proposed sculpture is required both from front and side, and that little alteration is possible once the armature is made. This apparent disadvantage is, in fact, an advantage as it forces the student to learn to draw accurately and to work with foresight and precision.

Materials and equipment as on p. 27. If the figure is to be of a size requiring a square mild steel armature, the following are needed:

vice (4" fitters' vice is adequate) attached to a suitable bench.

hacksaw.

short lengths of iron pipe.

spirit level to check that base is horizontal and thence that the figure is vertical.

black square mild steel ($\frac{3}{8}$" is smallest size obtainable).

galvanised wire.

galvanised clouts or nails or screws.

For a figure of up to, say, nine inches in height, galvanised wire will do—taller than that will require square black mild steel, the thinnest possible for the smaller figures, increasing in strength (i.e. thickness) for taller figures. Remember that an inch or two in height on a figure means a considerable extra weight of clay, as the size of the sculpture increases all over.

1 Draw an accurate full-size front and side view of the figure (Fig. 33).

2 Draw in the proposed armature on them (Fig. 33).

3 Measure the length of metal required. Allow sufficient for the base and a loop for fixing the armature to the board.

4 Find the middle of the metal, mark off with chalk the width of the top (a), and bend the two sides down (Fig. 33).

5 Apply the metal to the drawings, mark (b-b) with chalk and bend. Repeat for each bend (c-c, d-d, etc.). Check with the drawing each time.

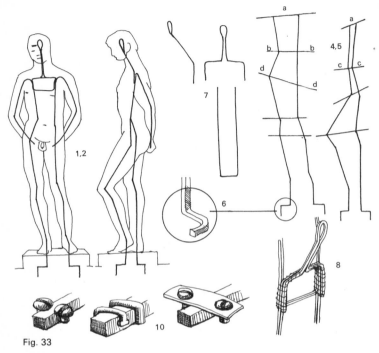

Fig. 33

6 Bend the feet at right angles, making allowance for the base.

7 Bend an iron for the head and another for the arms.

8 Bind them with thin wire to the main armature (Fig. 33).

9 Twist wire round the irons and round the torso. If the figure is fairly large, chicken wire may be wrapped round the torso and head.

10 Fix to base.

Leave the arms above the head while the binding together is being done and bend them to the correct position later. Note that the head iron is fixed in front of the main armature and the iron for the arms is behind.

It is wise to design the armature in a series of straights, each change of direction being precise and at a definite point. Curves are difficult to make accurately, although sometimes necessary.

Fig. 34 *Perseus* by Benvenuto Cellini, Florence

34

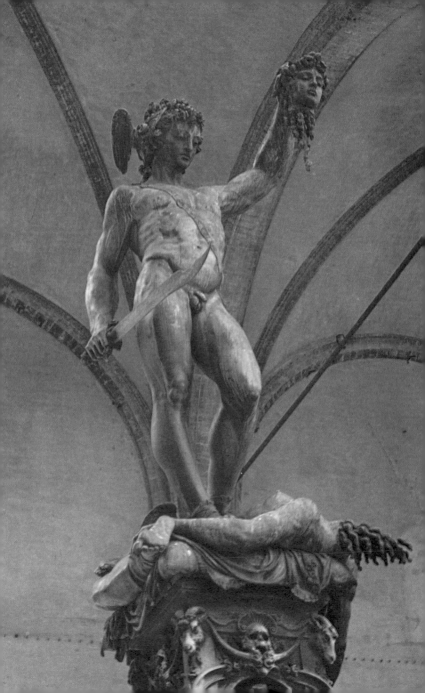

Note that for each bend on one side, there will be an opposite one on the other. In Fig. 33 the weight is on the right leg, so the left hip drops and the left knee comes forward. The shoulders lean back to the right to balance. Each length a-b, b-c, etc., is equal on both sides, only the angle being different.

If the armature is of mild steel, a vice is needed to hold it while bending. Slide a piece of iron pipe over it to act as a lever and, with a little practice, you will be able to bend accurately where you want and through the correct angle.

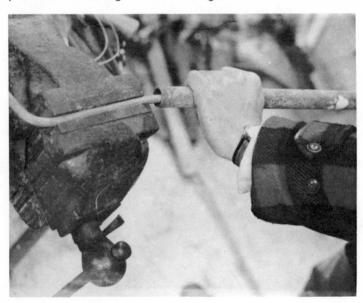

Fig. 35 Bending the iron in a vice

Modelling direct in Plaster of Paris

While this book is mainly concerned with methods and techniques, the division between aesthetics and technology is merely a device of convenience. It is usual to discuss them separately and at times it may be convenient to try to exclude aesthetics completely. But the very choice of materials will effect the end result and a desired result will demand particular materials and techniques.

Thus the methods of modelling described in the previous sections will tend to produce different results. Certainly the finishes will vary, but while, say, a portrait head will be much the same in terms of form (whether modelled with casting or firing in view), more complex sculptures will differ radically.

Modelling direct in plaster consists of applying plaster direct to an armature and then removing that which is surplus. This alternation between building up and rasping down is different both from modelling in clay and from carving.

Advantages One of the major problems for the beginner in sculpture is to break free of concern with detail as opposed to the major forms (concern with eyes, nose, mouth, as opposed to the total shape of the head). Working direct in plaster makes detail difficult to obtain so that the student is driven to the consideration of total form right to the end.

The casting process is dispensed with (i.e. the translating of the clay figure into plaster). This is an advantage where the continuous periods of time needed for making a mould are not easily found.

Certain types of sculpture, for instance a free-standing sculpture with no base, are difficult to carry out in clay because, if moved about to enable work to be carried out on the underside, the soft clay is likely to be dented and the form destroyed. In this case modelling in plaster is a good method because, once the plaster has gone off, the sculpture is handleable and can be turned over for working on the bottom.

Plaster will not withstand weathering however, and cannot be left out of doors for long periods.

The plaster

Plaster of Paris is made from gypsum which has been baked and finely ground. It is bought in the form of a white powder and, when added to water in the correct proportions, it returns to its previous hard form.

It readily absorbs moisture, even from the air, and should be stored in perfectly dry conditions. (A metal or plastic bin is excellent; for small quantities use a biscuit tin or flour canister with a tight-fitting lid, or a strong plastic bag). When in good condition, it feels fine and warm, but when it deteriorates, it feels lumpy and cold.

A batch of plaster ready for use is called a Mix.

Materials and equipment

plastic bowl.

plastic cup (for small mixes).

squeegee (rubber pan scraper) or kidney rubber (potters' equipment).

large spoon.

fine casting plaster.

storage bin.

Method

1 Take a plastic bowl and pour in a quantity of water. Sprinkle plaster into the water rapidly with the hand. Continue to do this until it begins to appear through the surface of the water fairly generally (Fig. 36).

2 Leave it for a few minutes until all the plaster has been taken up by the water and then, with either the hand or a spoon, agitate the plaster until it is evenly distributed throughout the water. This must be done with as little splashing as possible so that air is not taken up in the mix (Fig. 36).

Notes Judging the proportion of plaster to water is a matter of experience. If a wide, shallow basin is used, the plaster will come through the surface quite generally, but if a deep bowl is used it will, perhaps, break the surface only in the centre. As a rough guide for initial try-outs, an equal volume of plaster is added to

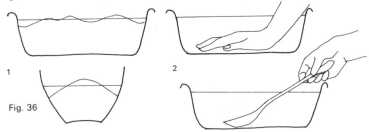

1

2

Fig. 36

the water. This should give an average mix. There is some latitude in the proportions, sometimes a weaker mix being required, sometimes a stronger. If the mix is too weak, however, it will not 'go off' properly (the term used to describe the process of the mix turning from liquid to solid); and if it is too strong, the hardening process will not be completed and the resulting cast will be too weak.

Make one or two trial mixes before applying the plaster to anything important. Not only will this enable you to see that the mix goes off properly, but you will be able to check the time taken. This may vary considerably according to the brand of plaster, age, strength of mix, even slight variation from bag to bag. Your estimate of the amount of work you can do with one mix, and consequently the size of the mix, depends on the setting time.

The plaster will remain thin for some time, but once it starts to go off it completes the process very rapidly. It can be used during this period; in fact at this semi-solid, clay-like stage a lot of important building-up may be done.

Once it goes beyond this stage and becomes like crumbly, half-dry clay, it is a mistake to try to use it, and any plaster left in the bowl should be thrown away. Inevitably there is some waste, however experienced you are, and until you have learned to judge the required amount it may be considerable; but structural weakness may be the result of using plaster that has gone too far.

Precautions Plaster which has gone off in the plastic bowl will break away quite easily, as it will from spatulas etc., and should be cleared out before a fresh mix is made.

Plaster should never be allowed to harden in a brush. The brush is sure to be damaged in cleaning.

Plaster should never be poured down a sink that is not provided with a special trap, as it will build up in the pipes and block them. It is best to let waste plaster harden and put it in the dustbin (garbage can).

If hands, brushes etc. are washed under the tap, water should be run for some time to ensure that all plaster is washed through the drains. Better still, wash hands and brushes in a bucket of water.

Plaster will not go off on an absorbent surface. Moisture is sucked from the mix which is then starved of water, upsetting the proportions (see note p. 42).

Modelling a standing figure

An armature made of mild steel or galvanised wire is ideal (p. 33). If mild steel is used, it should be painted with shellac or stove enamel to prevent rust stains discolouring the plaster.

Composition piping or aluminium wire (square or round) (pp. 27–8) may be used, but it must be so designed that it can be released from the back iron when the figure is sufficiently rigid to stand on its own.

A further possibility is to use mild steel for the legs only (which have to stand the greatest strain), and square or round aluminium wire for the rest, bound to the mild steel with thin galvanised or aluminium wire.

While this kind of armature is necessary for a sculpture such as a standing figure, where the two thin legs have to support a considerable bulk, some sculptures may be built over a frame of wood and chicken wire or, exceptionally, with no armature at all. The deciding factor is the form, the amount of strain on any given part of the sculpture, and hence the amount of reinforcing it will require.

Some forms may be built up with expanded polystyrene or plastic foam. It may be cut with a sharp blade, with a heated knife, or with a hot wire, and glued with a suitable adhesive. (Test the adhesive on a scrap of plastic foam to make sure it is suitable; plastic foams are destroyed by the solvents in some adhesives.)

Materials and equipment as for preparing a plaster mix (p. 38). also:

plasterers' spatulas (or kitchen knife).

scissors.

plaster rasps, Surform blades, or old saw blades cut into hand-sized pieces.

rifflers (shaped files) — use types for wood, not metal.

jute scrim — open woven hessian (burlap) — bought either in narrow rolls or wide sheets.

materials for armature (see pp. 27–8, 33).

Method

1 Build an armature and fix to a board.
Allow for a base at least $\frac{3}{4}''$ thick (Fig. 37).

2 Cut scrim (burlap) into strips, dip into a plaster mix, and wrap the armature (Fig. 38).

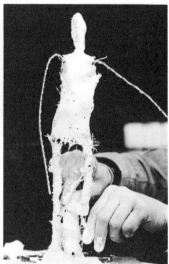

Fig. 37 Armature of black mild steel, galvanised wire for head and arms

Fig. 38 Scrim or burlap and plaster wrapped round armature

Fig. 39 Rasping off surplus plaster

Fig. 40 Adding plaster with spatula

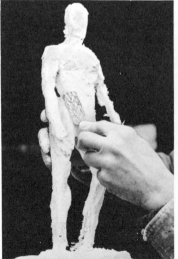

3 Continue building with plaster only (use spatula or old knife) (Fig. 40).

Rasp down with plaster rasp or Surform blade where too high (Fig. 39).

4 Make very small mixes towards the end—in a cup or even in a spoon.

Notes If plaster is put on a dry, absorbent surface, some of the water in the mix will be sucked out of it. The plaster will be starved of water and will not go off properly. Therefore ensure that the plaster surface of the sculpture on which you propose to add fresh plaster is damp. If the model has been left for any length of time, soak it under a tap or spray it thoroughly. If it has become bone dry, total immersion for several hours is advisable.

If plaster is to be added to a surface which is rather smooth, make a key (or texture to hold fresh plaster) by scratching the surface well with a sharp instrument.

Extremities are difficult to work sometimes and may chip and crack. A little PVA adhesive (white glue) added to the water of the mix for these parts will decrease this tendency.

When dipping scrim or burlap in plaster, it should have begun to thicken very slightly.

Wind legs and arms spirally with narrow strips. Smooth down as the plaster begins to go off to avoid projecting corners.

Carry scrim or burlap down from the legs into the base to ensure strength.

Very low parts may be bulked out with plaster and scrim (burlap) over crumpled paper.

Where a piece of scrim or burlap protrudes above the final surface level, cut a hollow round it and either cut it away or press it down. Then fill the hollow with plaster.

If nails or screws are holding the armature to the modelling board, do not develop the base to such an extent that it will be difficult to release later.

Do not be trapped into working too much from the front. Generally speaking, a sculpture should not have a front as such; it is important that it should be equally exciting from any view point.

There is an art in judging how much plaster to mix and how and when to use it. Except at the stage where the sculpture is being built up with scrim or burlap, only a limited amount of work can be done while the plaster is very runny. As it starts to

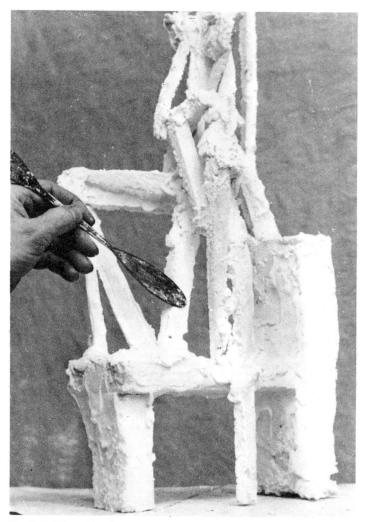

Fig. 41 Building with polystyrene (styrene foam) and plaster (see p. 63)

Fig. 42 Working in plaster, using Surform blade

thicken and is able to hold its shape, it can be applied rapidly. The going-off time being short, it is essential that you are quite clear how much plaster you will need for each mix and where you intend to apply it. This means that you spend time contemplating your sculpture. The most important work is done when you walk round your model, turn it, walk away from it, leave it for a short time. Only when you are convinced that you know exactly what is needed next should you make a new mix and apply it.

Fig. 43 Working in plaster, using plaster rasp

Portrait heads

Fig. 45 Albert Einstein by Epstein, bronze

Fig. 44 Portrait head, Ifé (Nigeria). Terracotta. In contrast to the Donatello portrait (p. 49), the treatment is uniform throughout.

There is a common misapprehension among beginners that a head is the easiest thing to model. A badly carried-out head is probably easier to make than a bad figure, because the head consists of a single lump of clay, whereas a figure may consist of several.

But the relationships within a head are not different in kind from the relationships within a figure. Sculpturally, the eyes are no more and no less important than the back of the neck. We see character and expression in a face and that may stimulate a desire to trap it and make it permanent, as might be done in a photograph. This is not possible, however, until the student has an understanding of the structure of a head; it is in the observation of how a particular head varies from a hypothetical norm that individual character appears.

Serious students would be well advised to study the form of the figure as a whole before tackling the head.

It is pointless to model a head from imagination until the student has a good knowledge of the form of heads and a clear idea of what he is trying to say.

Materials and equipment as for terracotta modelling and modelling on an armature (pp. 19, 27–8).

Method I, for casting or hollowing when complete (see pp. 68, 22)

1 Select a suitable modelling board and bracket on to it a vertical post approximately twelve inches high (Fig. 46).
2 Bend two loops of mild steel or heavy-gauge galvanised wire and fix to the top of the post (Fig. 46).
3 Suspend a 'butterfly' from the top of the irons to take the weight of the clay or wrap chicken wire round the top (Fig. 46).
4 Arrange the height of the modelling board so that the armature is on a level with your own head and that of the subject (Fig. 46).
5 Press clay firmly round the irons and the butterfly.
6 Begin to locate major points, e.g.
(a) height of chin in relation to the armature
(b) height from chin to top of head (note highest point)
(c) width of head (in front of ears)
(d) front of face and back of head.
These basic measurements may be made with callipers and must be related to the armature and to each other (Fig. 46).
7 Develop the form. Draw in the centre line up the middle of the face, over the top and down the back of the head. Draw in the eye level (approximately halfway down the head).
Locate the ear holes (see that they are opposite each other). Keep these lines and points and redraw whenever part of a line disappears (Fig. 46).
8 Stop before the head becomes overworked. The danger to be guarded against is adding too much clay and losing the crispness of the form. Do not worry about stopping before forms are fully developed.
9 If the sculpture is to be cast, cast as described on page 68. If the sculpture is to be hollowed, cut out a cap from the back of the head to reveal a suitable sized aperture and dig out the clay from the inside and around the armature until the head can be removed from the armature. Then lay it down carefully on a pad of cloths and dig out clay until it is between one half and three quarters of an inch in thickness. Treat the cap similarly and refix (Fig. 46). (See terracotta modelling p. 22).
10 Dry out thoroughly and fire.

Fig. 46

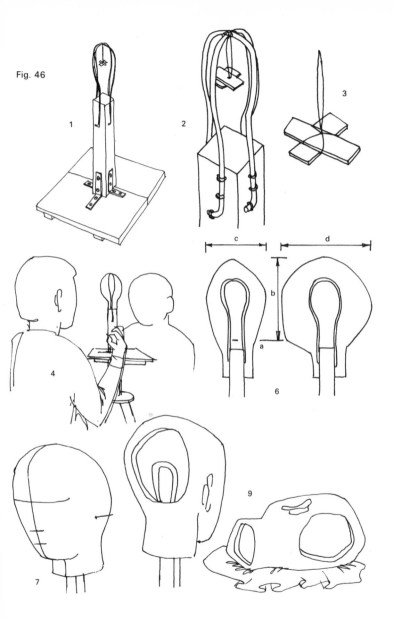

Notes Do not model looking down on a sculpture, unless the intention is that it should be viewed from above when sited after completion. The sculptor usually models a head which is looking at himself; so if he works looking down, the head will tend to look up, which causes it to lose dignity and become more intimate.

Turn the subject and your sculpture regularly so that an equal time is spent on all parts of the head. Do not concentrate just on the face.

For each point on one side of the head, there is an opposite point on the other. Relate the main points to each other.

The head is not symmetrical. Usually the right side of the forehead and the left jaw are heavier. Sometimes it is reversed. This is why your image in a photograph differs from that in a mirror. Examine this asymmetry and the way it affects the relationships of the head: look at the subject's head from above, and also from below, and compare with your sculpture looked at from a similar position.

Note the form of the bone under the flesh. Because the skull is stable and, except for the jaw, unmoving, points where the bone is just under the surface can be located exactly. If these points are fixed accurately, the soft flesh in between will be more readily understood.

The hair is part of the form and should be treated as such. Due to the slight changes in it from day to day, certain complications arise. At some stage, it will be necessary to make a decision to leave it in the form arrived at, whatever happens to the subject's hair later.

Eyes, mouth, nostrils should be allowed to develop as part of the form. Notice that the lips, if the colour is neglected, are simply changes in direction of the planes (a plane may be defined as a flat or curved area containing no major change of direction). Similarly, eyes must be permitted to develop as the surrounding form develops. It is a waste of time to try and attach them to an incorrect form.

Ears are complex forms which will need careful examination. Follow the general rule for modelling, i.e. determine major matters first and leave details to the last. Note the angle at which they leave the head and their size and level in relation to the head. Leave them thicker at the back than in nature, or they may be very fragile.

A desire for smoothness ruins the work of many amateurs.

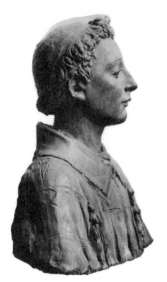

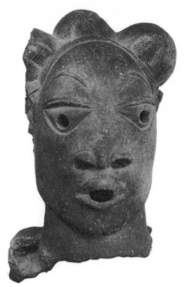

Fig. 48 Terracotta head, prehistoric culture of Nok, Nigeria

Fig. 47 Terracotta portrait called St Leonard by Donatello, S. Lorenzo, Florence. Note the free modelling and superficial drawing on hair and tunic as opposed to the highly finished face and neck. Nevertheless the form is accurately and completely stated throughout.

Develop the form with smaller and smaller pieces of clay until eventually it becomes fine. Smoothing with the fingers or a modelling tool before the forms are adequately developed is the besetting sin of the beginner, and is disastrous.

A smooth finish is not necessarily the most desirable. Note the very loose modelling and open finish on Epstein's head (Fig. 45), and the firm grasp of structure and form it nevertheless shows.

No mention has been made of expression, etc. The student is strongly advised to pay no attention to this aspect. If a careful and thorough examination of the form is made, the expression and character of the subject will arrive of itself, due to the unconscious awareness and selectivity of the student. Attention to effect and expression at the expense of form results in bad sculpture.

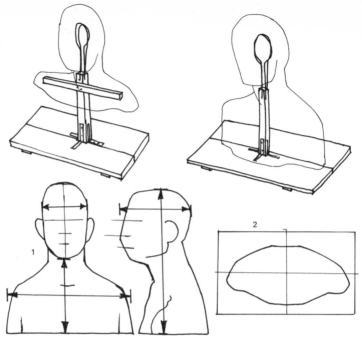

Fig. 49 Two methods of supporting a bust, main dimensions, plan drawn on modelling board

Method II, building hollow

While heads may be made by this method, it is more suitable for building busts (i.e. head and shoulders). It demands a clear idea of basic proportions before starting, and it is advisable to use the previous method first—until experience is gained.

Modelling a bust, built hollow

Modelling a bust is basically no different from modelling a head.
1 Determine the basic shape of the bust with main dimensions (Fig. 49).
2 Draw the plan on the modelling board (Fig. 49).
3 Start building as described in terracotta modelling (p. 23), leaving the clay to firm up after every four to six inches.
Build the main form with care and accuracy and leave all details till later. (Note that the head is far from round, being flattened at the sides).
4 Develop as described in method I.

Relief modelling

Relief may be defined as sculpture that is part of or attached to a plane, and cannot exist apart from that plane. It is intended to be seen from one view-point as opposed to the multiple view-points of sculpture in the round.

It may consist of the very slightest elevation of the subject from the background (low relief), and ceases to be relief only when it detaches from the background and becomes sculpture in the round.

Reliefs are usually designed to be mounted vertically and seen from the front.

Fig. 50 Relief by Bonano Pisano, bronze

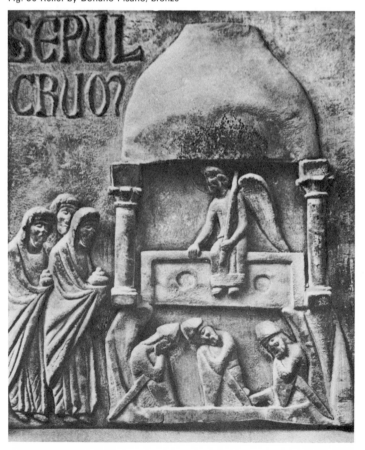

If the relief is out of doors, it will tend to be lit from above; if indoors, this may not be so. The quantity and direction of light will vary both in and out of doors.

As a relief must be either part of or attached to a flat surface, it should not be considered in isolation from that surface.

The relief is nearly always flattened. Almost never is it a figure sliced down the middle and attached to the background. We tend to read the subject as being in front of the background. It offends the senses if it appears that the background is cutting through the subject, rather like someone caught between sliding doors. It does not mean that the flattened figure in its entirety need be in front of the base plane, however. The flattening of the subject creates a new set of relationships which accommodate the background.

At the heart of relief sculpture is drawing, which means illusion. A sculpture in the round can be observed from many view-points and our understanding of it is increased the more we observe it from every angle. But a relief is a kind of three-dimensional drawing or painting that can be viewed only from the front; if we move much to the side, the relationships become so changed that its meaning may well be incomprehensible.

The flattening may be very great, as in Egyptian low or sunk relief, or very little, as in some Greek reliefs; indeed figures almost completely in the round occasionally appear at the front of a relief and flatter figures appear in the distance. There is a hierarchy of depth; relief becomes lower with implied distance. The flatter the figure, the more distant it seems.

Low relief tends to be on two levels only; that is to say, the form in relief is raised to a single level above the background plane. There may, on the other hand, be a number of planes.

High relief gives greater freedom in organising multiple levels, but there is no advantage in increasing the number of levels unnecessarily. Usually four is enough.

Fig. 51 Relief of torso, showing flattening

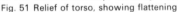

sunk right
low right
high right

wrong

sections of relief

Fig. 52 *The Metamorphosis of Actaeon*
by Mogens Bøggild, relief, Denmark

Fig. 53 Greek relief, Delphi, *c.*525 BC

A change of level usually, but not invariably, coincides with a change of plane. The chariot relief, part of which is illustrated in Figs 53-54, is 27″ high and 66″ long. It is part of a frieze and has a maximum depth of 3″. There are four levels, although, among the complex of the horses' legs, two half levels are used, making six. (The original is carved in marble and therefore the limitations are somewhat different from a modelled relief. The top surface would be strictly limited by the thickness of the marble slab. The sculptor has obtained greater depth in places by cutting back into the background, partly to emphasise form by increasing the shadows, and partly to allow space for the greater number of levels among the legs.)

In the illustration *The Metamorphosis of Actaeon* (Fig. 52), there is a large top plane which takes in much of the sculpture, an intermediate level, and the background. In places, these main levels are subdivided: on the right, 1-hand, 2-horn, 3-face, 4-neck, 5-background.

Sometimes the change in level is sharp and precise, sometimes it is a steady decline. (Actaeon's right leg: knee on plane 1, foot on 2).

Notes If possible, work on the relief in a vertical position, as it is intended to be viewed.

Vary the lighting conditions as you work. If produced under

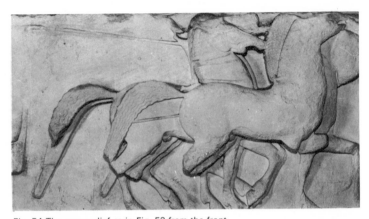

Fig. 54 The same relief as in Fig. 53 from the front

Fig. 55 Incised relief in stone of Akhenaten, Egypt, c.1600 BC

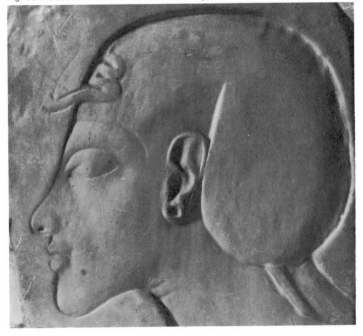

only one particular set of lighting conditions, the move to a different situation may prove disastrous, lighting up all sorts of unobserved faults.

Work systematically:

(a) Make initial drawings or sketch models.
(b) Decide on the maximum depth.
(c) Decide on the main planes.
(d) Develop within these limits.

Junctions where a form leaves the background plane or where planes meet should be firm and precise.

Terracotta reliefs

Clay should be heavily grogged (one part grog or sand to three parts clay). There is a great tendency for a flat sheet of clay to warp when drying, which the grog or sand minimises.

It must be clean and free from fragments of plaster etc.

Materials and equipment as for terracotta modelling (p. 19).

Making a small relief panel in terracotta

1 Work out the basic design of the relief on paper or as a clay sketch.

Decide on the number of levels.

Decide on the maximum depth, say $\frac{1}{4}''$.

2 Choose a suitable board. Near the bottom edge, nail a batten or wood strip $\frac{1}{2}''$ deep to support the clay when the board is raised.

3 Press clay on to the board to a thickness of $\frac{1}{2}''$. Join the lumps so that there are no cracks and no air is trapped.

4 Support the board at a convenient working height so that it is nearly vertical.

5 Draw the main lines of the relief by tracing from the drawing.

6 Build the sculpture, bearing in mind the following points:

Keep the levels as simple as possible.

Keep junctions (between relief and background plane and between parts of relief) clear and clean.

7 Allow the sculpture to dry slowly. If necessary, cover it loosely with a plastic sheet to slow the drying process.

8 When leather-hard, tip the relief off the board on to a pad of rags and see that the back is free from cracks and faults. Angled holes may be made in the back at this stage for mounting (p. 61).

9 Turn the relief back on to a gridded base (e.g. an oven rack) so that air can reach all sides equally, and dry out slowly. If care

Figs. 56-57 Low relief by Geoffrey Clarke, aluminium. Note irregular divisions. Castrol House, London

is not taken and drying is uneven, the relief will warp.

Remember that clay shrinks when it dries and consequently, if it is not permitted movement during the process, it will crack.

10 Fire carefully, allowing the temperature to rise only slowly.

Note If the relief is high, protruding far from the background plane, there will be a tendency for the panel to be 'front-heavy' and consequently liable to tip forward while you work.

(a) Wire the board back when in the upright position so that it will not tip forward with the weight of the clay as you model.

(b) Drive a few long nails into the board through the clay base at points where the relief will be deep. They will help to take the weight of the clay (this is only suitable for small reliefs).

Hollow out parts of the relief that are too thick to fire safely.

Larger relief for terracotta
Low relief

1 To stop the clay falling off the board, drive galvanised clouts or nails into the board and twist wire between them (Fig. 58). Press clay around the wire, which should only be fractionally above the board.

2 Make sure the board is securely held in the vertical position and will not tip forward.

3 When the relief is completed and at the leather-hard stage, or slightly before, cut it into sections, either as rectangular tiles or in irregular shapes, taking account of the modelling (Fig. 58). Carefully remove the sections from the board and repair the back where it has been removed from the wire. Lay the sections together on a horizontal surface and repair any damage done in cutting.

4 Dry out and fire as described above.

5 Fix the sections together on to background, e.g. wall or chipboard (wood-waste building board), with cement or adhesive.

High relief

The larger the relief, the greater the initial preparation required.

1 See that the board is of adequate strength and dimension. It is simplest to arrange the board at such an angle that there is no danger of it tipping. A large relief may contain several hundred pounds of clay and could be dangerous if it fell.

If it is worked vertically, fix it securely in a near vertical position at a convenient level. Nail or screw a batten or wood strip to take

Fig. 58 Board with wire, relief divided into rectangular tiles and relief divided
irregularly

the weight of the clay. Bracket out pieces of wood at convenient
points to take the weight of the clay. Wire may be used as
described above or chicken wire fixed with clouts or nails to
act as a key (Fig. 59).

All keying on to the board must be such that the finished relief may
be removed easily.

Very large reliefs may not be suitable for terracotta unless built
in sections and assembled afterwards.

2 Divide the relief into suitable parts, remove from the board and
hollow. Leave supporting ribs of clay in the hollowed part to
prevent sagging during drying and firing and to give greater
strength to the sculpture (Fig. 59).

3 Dry and fire as described.

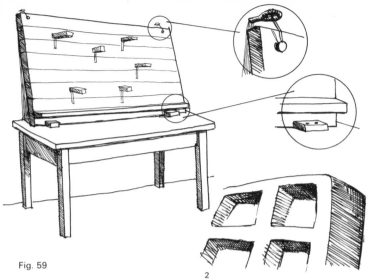

Fig. 59

2

Building a relief horizontally

Any relief may be made horizontally: if small, on a table; if large, on the floor. This obviates the problem of suspending it during building. It means, however, that it cannot be seen as it will be seen when completed and mounted vertically. The lights and shadows will be quite different and it requires a considerable amount of experience to visualise the result. Even an experienced sculptor will not be able to judge the results precisely.

Clearly, then, it depends on the nature of the relief panel as to whether this method is feasible. If the relief demands a careful adjustment of shadows, the horizontal method cannot be used. A relief broadly treated may be made this way; in which case a small model to check the light and shade in the vertical position should be used.

A relief to be cast

This may be fixed back very securely on to the modelling board as it does not have to be released later. For a large relief, a sheet of chicken wire, fixed at intervals with galvanised clouts or nails, is ideal. High parts may be built up with chicken wire shaped to fit the design so that less clay will be needed. These high parts may be suspended on brackets (Fig. 59).

Leave two inches or more of board round the edge of the relief for the plaster mould.

The mould is made of plaster, but the cast may be of plaster, concrete, or polyester resin and fibreglass.

While clay for terracotta must be free from impurities, the ordinary studio clay is used in all other circumstances.

Relief built direct in plaster

(for plaster technique see Modelling direct in plaster p. 37).

If a very thin base (background plane) is desired, put a clay wash (clay thinned down with water) over the board and lay on it a layer of Plaster of Paris approximately $\frac{1}{4}''$ thick. While it is still wet, place scrim (or burlap) dipped in Plaster of Paris over it and pat down to exclude air. Build the relief on this.

If a deeper base is required, build up with chicken wire and lay the scrim (or burlap) over it.

Alternatively build up with expanded polystyrene or other plastic foam and cover with scrim (burlap) and plaster (see p. 63).

The higher parts of a high relief may be built in the same way. If the wire is fixed back to the board, ensure that it can be released unless it is intended to incorporate the board as a permanent part of the relief.

Reliefs in intaglio

This means making a mould direct, by cutting into the clay so that the final cast is taken directly off it.

Make a layer of clay of suitable dimensions on the bench or on the floor. Cut away clay with a wire tool so that the design is lower than the clay surface. The surface may be textured by pressing it with any suitable object. Decorative elements (shells, stones, wood, metal, etc.) may be laid on or pressed into the surface of the clay so that, when the surface is covered with plaster, they are pulled away and incorporated in the cast.

When casting, be careful that plaster fills all corners. Cover the entire surface with a layer $\frac{1}{4}''$ to $\frac{1}{2}''$ thick and reinforce with scrim or burlap; also wood or metal if necessary (see Casting p. 83).

Remove the plaster cast from the clay mould with care. It may be necessary to remove as much of the clay as possible before

trying to lift the cast if the relief is high, if you can get at the clay to do so. The cast may also be made in concrete by this method.

The methods described in this chapter are in the main traditional, but in fact there is much room for experiment, as suggested above. Today much is done with assembling materials on a background. For example, sections of wood mouldings have been glued down to chipboard and the whole painted. Almost any material may be set in polyester resin (see p. 92) and the resin itself may incorporate added fillers or pigment. Materials may be pressed into wet concrete or wet concrete may be textured and treated.

The possibilities for experiment are endless and it is well worth observing the work of various artists in this form related to architecture.

Mounting reliefs

Small reliefs for mounting on walls indoors should have either angled holes drilled into the back, which can be slipped over accurately sited screws in the wall (Fig. 60) or, if the relief is of plaster or cement, wire loops attached firmly to the back with scrim or burlap (Fig. 60, p. 62).

A relief intended to be mounted out of doors must be made of a suitable material (e.g. concrete or well-fired terracotta). If it is to be suspended, use angled holes as described above, but instead of screws in the wall use short lengths of phosphor bronze rod (or similar non-corroding metal) cemented in, so that there is no danger of rust weakening the supports.

If the relief is to be set into or incorporated into a wall, it should be well cemented in and phosphor bronze studs at the top and bottom may be used to ensure that it does not tip forward.

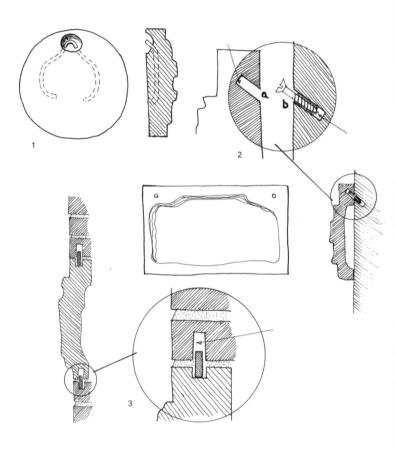

Fig. 60 1. Wire loop, dotted line shows wire buried in plaster or cement and well scrimmed in

2. Hole drilled in back of relief and slipped over screw set in wall at an angle a. hole in relief, b. screw in wall

3. Hole drilled in brick, deep enough that rod may be held up until the relief is *in situ* and then allowed to drop in place

Expanded polystyrene (styrene foam)—its uses

This is a foamed plastic which is extremely light for its bulk. It is used widely for packaging and in the building industry for insulating.

Its usefulness to the sculptor is enormous. Instead of building an armature of wood and chicken wire it is often possible to build a core of polystyrene (called styrene foam in America) and work over it with plaster or other materials. Mild steel armatures may be bulked out with it; indeed, the bulk of a sculpture may be built out in foam so that only a very thin skimming of plaster is required over it.

The second way that the sculptor uses the material is directly as a mould.

As it cuts very easily and is so light, it is used for light sculptures and constructions of a temporary nature for decor and decorative purposes. It may be glued with the appropriate adhesives and painted.

It may be bought in small tiles half an inch thick at handyman shops (in Britain), in various small shapes in dime stores in America, or in large sheets and blocks at plastic suppliers. It is coarse in texture, consisting of globules of the material adhering together, but may also be obtained in a fine, close, granular texture.

Fig. 61 Working a block of polystyrene (styrene foam) with Surform, as a core for plaster

Cutting

Unless the tool is sharp and fine it will tend to tear the foam. A sharp knife (like a saw-toothed bread knife) or a hacksaw blade is excellent. As it melts very easily, a widely-used method is to cut with a hot wire.

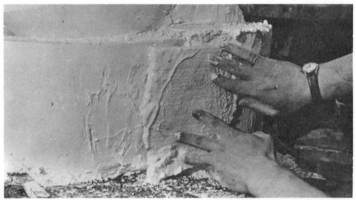

Fig. 62 Polystyrene (styrene foam) dipped in plaster and squeezed on

Fig. 63 Working over in plaster with a spatula

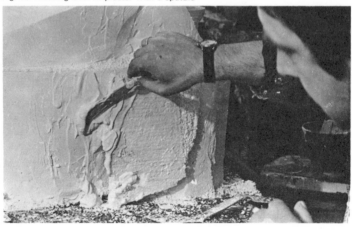

An electric soldering iron or any lightly heated metal object will cut channels and make holes. Bear in mind that heat vaporizes some of the foam and the fumes can be toxic: work with proper ventilation.

It may be rasped with plaster rasps, cheese graters, etc. and can be sandpapered.

Joining

If used with Plaster of Paris, polystyrene foam may be joined with the plaster. Many adhesives destroy it. Suitable adhesives are of the non-solvent type, e.g. Copydex, Unibond. Many white glues (water-soluble when wet, insoluble when dry) will do the job.

Materials used with expanded polystyrene

Plaster and concrete may be used direct against polystyrene. It will tend to adhere to them, but any remaining foam can be burnt off with a blowlamp or propane torch or dissolved with thinners. Again, beware of fumes and work in a well-ventilated area. A coat of emulsion paint over the polystyrene will assist separation.

If used as a core, suitable reinforcement must be added to the plaster or concrete laid over it, as the polystyrene, which can be left inside, has little strength.

Polyester resin will destroy polystyrene, so the foam must either be skimmed with plaster or given several coats of emulsion paint to ensure that it is absolutely isolated from the resin. Even a small hole in the separator will permit the resin to burn a large hole in the polystyrene (see polyester resin, p. 92).

Expanded polyurethane, another plastic foam, is not affected by polyester resin nor by most adhesives. It is, however, much more expensive.

Precautions As the dust from polystyrene is so light and, with melting, minute threads of the material are given off, it is considered wise to wear a mask over the nose and mouth if using it much. These may be obtained from industrial suppliers and chemists or drug stores.

Some other modelling materials

Plasticine

A material familiar from childhood to most people. Less pleasant to handle than clay and less easy to control, especially when new. Does not dry out and therefore needs no cover while modelling. May be used by itself or on a core or armature. Plaster casting is more difficult than with clay, but it is readily rubber-moulded (see p. 97).

Wax

The traditional modelling material where it was intended to cast in metal. The wax was modelled over a core, a case (or investment) made over it, like a mould, the wax melted out and the space filled with metal. May be bought ready or prepared by melting equal parts of beeswax, paraffin wax and resin plus a colourant.

Method – soften it with the fingers and apply to a wire armature or a core. Or sheets may be made, cut up, warmed, shaped and joined. May be cast or kept as it is, although it is liable to be damaged, and may crack with age.

Vinyl modelling compound

A PVC (polyvinyl chloride) based compound, terracotta-coloured and the consistency of putty. When cured in a domestic oven, becomes permanent and may even be kept out of doors. Either make a core of the material or, for larger sculptures, make one of glass-fibre wool and model over. It may also be used on an armature and, as it shrinks only slightly during curing, can remain on it. Cure in a domestic oven, following manufacturer's directions as to temperature. Time taken, from twenty minutes to four hours, depends on thickness of compound—the thicker it is, the slower should be the curing. If undercured, it remains cheesy and should be returned to the oven to complete the process. Over-curing makes it brittle.

Self-hardening clays

(Plastone in Great Britain). A paste the consistency of soft plasticine. Hardens when exposed to the air. A core is made of the material and allowed to firm up. Model over it with Plastone, or a

similar self-hardening clay. It may also be used on armatures. It is self-hardening; the surface may be damped and smoothed. It will not stand the weather and is suitable for small sculptures.

Fire resistant materials

(Pyruma and Tiluma in Great Britain). These are materials used for sealing fire-bricks, etc. They are similar in many ways to self-hardening clays and can be used in the same way. I have seen quite a large figure built of this material over an armature. Shrinks and tends to crack slightly in these circumstances. Most suitable for small sculptures.

Plaster impregnated gauze, like that used by doctors for immobilising broken bones, is bought by some sculptors in the United States for modelling in plaster. Expensive, but more convenient than scrim or burlap dipped in liquid plaster. Merely dipped into warm water and laid over a simple armature, it hardens rapidly, and plaster may be applied over the gauze to build thickness and texture.

Plaster casting

Making a plaster waste mould of a portrait head

A head is chosen as an example, but any simple shape may be used. Do not try to cast a more complicated figure until you have mastered the casting of a simple one.

The mould is made in two parts to facilitate removal of clay.

Method I, using brass shim

Shim: thin brass sheet. Cut
 with scissors into
 strips. Snip up into
 tapering pieces. Kink
 to act as key, to
 enable the two halves
 of the mould to be
 fitted together.
 The clay sculpture
 must be damp.
1 Draw a dividing line
 right round the head
 (Fig. 64).
2 Make vertical wall of
 shim along the
 dividing line (Fig. 64).
 Trim off projecting
 corners with scissors.

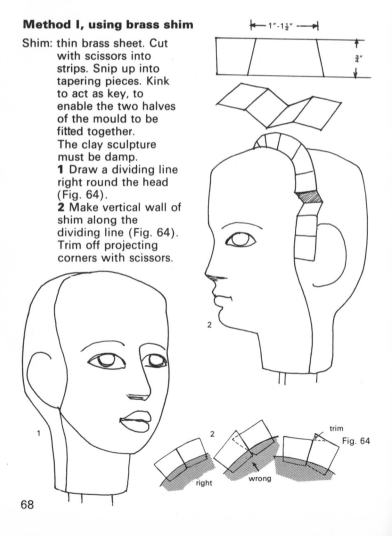

right wrong trim

Fig. 64

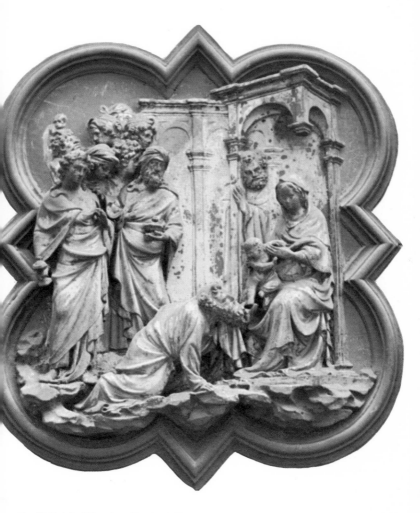

Fig. 65 Detail of first door, Baptistry, Florence by Lorenzo Ghiberti, bronze

Applying the plaster will cause a certain amount of splashing, so it is wise to do the work in a place which can be cleaned up easily. Cover anything likely to be damaged, wear an overall that covers your clothes adequately, and wear old shoes.

1 Pour a suitable quantity of water into a bowl and colour it with a water-soluble pigment like a cheap dye. (The reason for this will appear later.) Prepare a mix as described previously, see p. 38. This mix should be on the thin side but, of course, well within the limits of a good mix.

2 With the fingers, flick the coloured plaster all over the sculpture until it is completely covered (Fig. 66), blowing it into corners that it will not reach readily. Build up this layer until it is between $\frac{1}{8}''$ and $\frac{1}{4}''$ thick.

3 As the plaster thickens, build it up on either side of the shim.

Add blobs as a guide to the thickness of the supporting coat.

Scrape the edge of the shim clean, taking care not to disturb it (Fig. 67).

This first, coloured coat gives an exact replica of the sculpture; the second coat, applied over the first, is intended to support the first and give it sufficient strength for handling.

Fig. 66 Applying the coloured coat Fig. 67

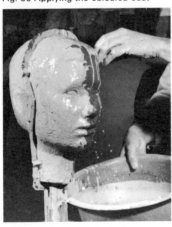 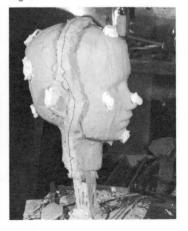

4 Make a mix, not coloured, and a little stronger than the first.

5 As the plaster begins to thicken slightly, and starting at the bottom, build up the mould to a thickness of $\frac{1}{2}''$ or $\frac{3}{4}''$.

6 Before the plaster goes off completely, clean off the edge of the shim (Fig. 68).

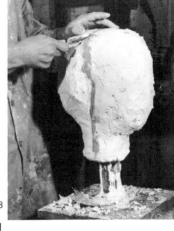

Fig. 68

Method II, using a clay wall

1 Draw a line dividing the head into two parts.
2 Cut slices of clay of suitable dimension (Fig. 69).
3 Build vertical wall of clay along the line, supported by knobs of clay (Fig. 69).
4 Cover the back of the head with paper (Fig. 69).
5 Make a coloured mix. Cover the front to a thickness of $\frac{1}{8}''$-$\frac{1}{4}''$.

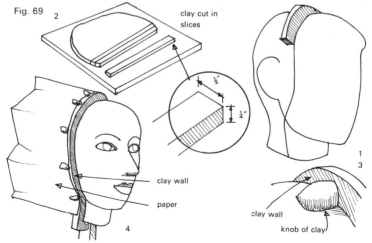

Fig. 69

clay cut in slices

clay wall

paper

clay wall

knob of clay

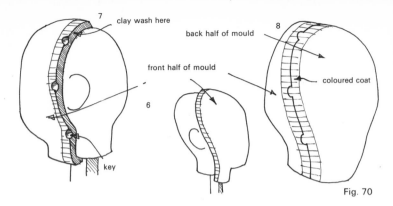

clay wash here

back half of mould

front half of mould

8

6

coloured coat

key

Fig. 70

Build up against the clay wall. Add the second supporting plaster coat. Scrape level with the clay wall.

6 Remove paper and clay wall, tidy edge, cut keys (Fig. 70).

7 Paint clay wash (clay thinned with water) along edge of plaster mould (Fig. 70).

8 Build back part of mould for back half of head (Fig. 70).

Removing the mould

Leave the mould for ten or fifteen minutes to let the plaster go off completely. The mould must now be freed from the clay. This is done by introducing water between it and the clay.

1 If the mould is small, immerse it in water; otherwise drip water around the seam between the two halves until it begins to open.

2 Dig out one or two pieces of shim, if you have used the shim method, to assist the entry of water under the plaster. Avoid damage to the inner edge of the mould.

3 As the seam opens, work the two halves of the mould with the hands. Pour water into the gap continuously. If the clay is hard and the sculpture is at all sizeable, this operation may be tedious, but do not use undue force; it is very easy to break the mould.

Usually the clay form is in a damaged state after the mould has been removed and is dispensed with.

Cleaning and preparing the mould

The mould must be cleaned and sealed.

1 Remove any large pieces of clay. With a piece of moist clay, dab out the small pieces which stick in odd corners.

2 Wash out, using a soft brush (a clean house-painter's brush is suitable). Use only the side of the brush; the ends of the bristles may damage the soft plaster.

3 Seal. Make a strong solution of liquid detergent, soft soap, or soap flakes. Brush the soap over the inner surface of the mould and its edges, avoiding damage to the surface but producing a good lather. Wash off the soap with clean water and repeat the process. The inside of the mould should now have a slight gloss.
4 Drain off surplus water.
5 Put the two halves back together and fix in place by winding thin galvanised wire round. Twist tight with pliers. Or join with strips of scrim or burlap dipped in plaster and placed across the seam.
6 Seal the seam by rubbing a little plaster round it. Only a small mix (a tablespoonful) is needed.
The mould is now ready for filling.

Filling the mould

A sculpture the size of a head is usually cast hollow. (Small sculptures or slender parts of a sculpture are made solid.)
1 Make a plaster mix and pour it into the mould through the hole at the bottom of the neck.
2 Roll the mould round and round until the inside is evenly coated with a layer of plaster about $\frac{1}{8}''$ thick.
Make sure that the plaster covers the inside of the neck.
Tip surplus plaster into the bowl and pour back into the mould.
3 Continue to build the coat in the same way as the plaster thickens, but pour out the surplus before it becomes very thick, otherwise a large blob will develop which will drag the plaster off the inside of the mould as it turns and then set in a lump.
4 Make another mix and repeat the process until an even layer $\frac{3}{8}''$ to $\frac{1}{2}''$ thick lines the mould, becoming a little thicker round the entrance. There is an element of guesswork in judging the thickness of the cast, but the thickness round the neck helps and, of course, the quantity of plaster poured in will be a guide.

Chipping out

1 Leave for fifteen or twenty minutes. Remove the wire or scrim that joins the halves.
2 Make a bed of clean rags. On it place the mould.
3 Chip away the mould with a blunt chisel and mallet, starting near the top and at the seam. The coloured coat will appear and warn when you are approaching the cast. Work outwards and

downwards until the mould is entirely chipped away.

4 Chip away remaining parts of the coloured undercoat. Pick out pieces of mould that are caught in holes or hollows. Scrape away parts of the seam that are left raised on the cast and similar faults.

5 Make a small mix of plaster and, first wetting the faulty part, make good any faults or damage.

Notes Hold the chisel vertical. The aim is not to cut away the mould but to stun pieces off. Always use a blunt chisel.

Do not chip away large pieces, as this may cause damage to the cast. The piece being chipped away should be smaller and weaker than that remaining. Around complicated areas (eyes, ears) work very carefully, chipping only small pieces away.

Never lever or pry off a piece, as some of the cast may come away with it.

Casting a small standing figure

1 Draw a line dividing the figure into two parts (Fig. 73).

2 Build a brass shim wall following the line.

Shim between leg, arm and body.

Small spaces may be filled with a clay 'pill'.

Divide the back into suitable sections with horizontal shim walls (Fig. 75). These sections are called caps.

Note (a) if made with back iron, make a pad of clay round the iron (Fig. 73).

(b) arrange the shim wall so that the top cap comes off first.

Fig. 71 Chipping out, showing angle of chisel

Fig. 72 Chipping out, showing the coloured coat underneath

3 Apply a coloured coat. Build up the thickness along the seams. Clean off the edge of the shim.
4 Prepare reinforcement: heavy wire for a very small mould; mild steel or wood for a larger mould.
5 Place reinforcement in position and apply supporting coat. Clean up round the base.

Note: warping The mould must be reinforced to prevent warping. It should be supported with wedges or blocks when laid aside during the casting process.

Note: reinforcing Because plaster is brittle, slender elements must be reinforced. This is usually done with galvanised wire in small sculptures and mild steel sealed with shellac or stove enamel to prevent rust staining in larger ones (Fig. 78).

Preparing and filling the mould
6 Remove the mould. Trickle water on the seam.
Dig out one or two pieces of shim to permit water to enter under the plaster more readily. When the seam begins to open, work the

Fig. 73

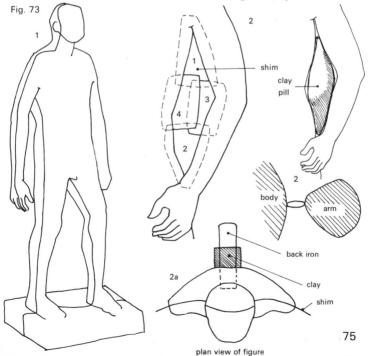

plan view of figure

75

cap backwards and forwards, pouring on more water until it comes free. Remove remaining clay and lay down, supporting it with blocks or wedges so that it does not warp.

Continue with each section down the back.

7 Clean, fill hole in mould left by back iron. Make vents to allow air to escape from any point where it would be trapped during filling (Fig. 78).

8 Bend reinforcement:

heavy galvanised wire for small figure,

mild steel (painted with shellac or stove enamel) for larger.

Twist thin wire round the reinforcing (Fig. 78).

9 Seal mould.

10 Fix the reinforcement in place with dabs of plaster. (Support the metal with pellets of clay until the plaster goes off.)

Check that no slender parts of the mould are blocked.

11 Join up the mould and seal the seam.

12 Invert the mould and support firmly. (A small mould may be put in a bucket.)

13 Make a mix big enough to fill in one pouring.

Pour through one leg. Jog the mould at intervals to release air bubbles.

Keep a knob of clay handy to block vents or leaks in the mould.

Fill until the plaster stands above the edge of the mould.

14 When plaster becomes firm, scrape base flat with straight-edge.

Fig. 74 First, coloured coat, showing shim Fig. 75 Back view showing divisions

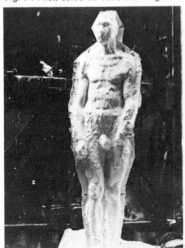

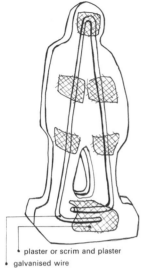

plaster or scrim and plaster
galvanised wire

Fig. 76 Wire reinforcing

Fig. 77 Wood reinforcing

Chipping out

1 See that the pad of material supports the mould adequately.

2 Chip off the reinforcement, taking care not to put an undue strain on the cast by levering or prying.

3 Start near the top and work downwards, turning the mould and working on both sides.

Notes: Work carefully on chipping the mould from slender parts of the cast. Ensure they are well supported and that no heavy piece of mould is left on them in such a way that it will cause undue strain.

Fig. 78 Layout of reinforcement

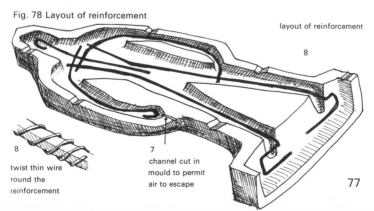

layout of reinforcement

8

8

twist thin wire round the reinforcement

7
channel cut in mould to permit air to escape

Casting a large standing figure

The principles and method are the same as for casting a small figure. A two-foot high figure can be cast as described in the previous section; a large figure requires additional information.

Making the mould A life-size figure is considered, although techniques described may be applied to much smaller figures.

1 Build the walls of shim one inch deep. Press it deep enough to be firm. The horizontal walls in particular will have to stand some weight of plaster.

Arrange the walls in such a way that each section will come away in turn with the maximum ease.

2 Bend up the mild steel reinforcement for the caps. It should be shaped to fit round the perimeter of the cap but not too close to the edge, otherwise it may weaken the section rather than strengthen it (Fig. 79).

3 Build the mould. The whole figure cannot be covered in one go, therefore it is necessary to start from the bottom and work up.

(a) Make a coloured coat and cover the base and as much of the legs all round as can be managed with one mix. Never finish one coat immediately underneath a horizontal wall of shim.

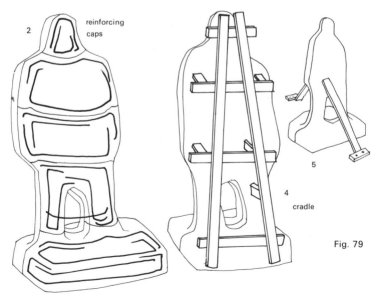

Fig. 79

Stop several inches below the wall so that the next lot will cover both sides of the shim wall. Finishing immediately under it may cause displacement of the pieces of shim.

Build this coat up on either side of the shim.

(b) Build the supporting coat, starting at the bottom. Carry it up to just short of where the coloured coat has reached.

Incorporate the reinforcement in the supporting coat.

(c) Work up the figure in stages until the mould is completed.

Note When applying plaster round the shim, ensure that no pockets of air are left, otherwise the mould will be weak at the very place where maximum strength is desired.

Blow the coloured coat into these corners and press the supporting plaster in with a spatula.

4 Make a cradle. This consists of a frame of wood scrimmed on to the front part of the mould, which is big and unwieldy.

It enables the mould to be handled more easily, increases its strength, and is a level base on which it may be rested when lowered to the floor for cleaning and filling. It may be made piecemeal by scrimming the wood to the mould at appropriate points and scrimming the pieces of wood to each other with long narrow strips of scrim or burlap dipped into plaster (Fig. 79).

Moisten the mould before scrimming the cradle on to it. Keep the bottom clear of the floor to facilitate movement later.

5 Remove caps as described previously. Wedge up to avoid warping.

Remove the clay and the armature from the front of the mould and lay the mould section down on the cradle. (This may require more than one person.) Wedge up the cradle if necessary (Fig. 79).

Note It may be necessary to support the front of the mould with battens or wood strips tied to the cradle and fixed to the floor while dismantling the mould.

Preparing and filling the mould (the figure will be cast hollow and in sections).

6 Clean and seal the sections of the mould.

7 Fill each section separately:

(a) Soak the section and allow to drain.

(b) Apply an even layer of plaster $\frac{1}{4}''$ thick over the surface of the mould to the edges. Wipe the edges clean.

(c) When the first coat goes off, apply pieces of scrim or burlap dipped in plaster. Dab them down well with a brush. Adjust them

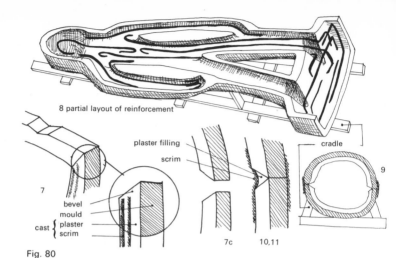

8 partial layout of reinforcement

plaster filling

scrim

cradle

7

bevel

mould

cast { plaster
scrim

7c 10,11

9

Fig. 80

neatly to the edge. The total thickness need be no more than $\frac{1}{2}''$. The edge should be bevelled so that, when two sections are put together, a V-shaped gap is left in the cast (Fig. 81).

(d) Clean the edge of the mould.

8 Apply reinforcing rods:

It is better to use several thin rods rather than one thick one in a narrow section. A single thick rod may bend, but several thin ones laid round the inner perimeter give much greater strength. In the leg, for example, three or four rods anchored well into the base and carrying up into the torso will be adequate. Distribute them on the inside on the cast and plaster and scrim them in place. Do as much reinforcing as possible in the main section.

Place the sections of the mould back in place and ensure none is ill-fitting (due to the bevel on the edge not being adequate, or a badly placed iron, or plaster on the edge of the mould).

Correct any faults and remove the sections.

Joining the sections

9 Place the first cap (i.e. the head and shoulders) in position and scrim it in place.

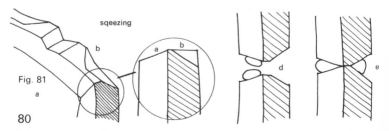

sqeezing

b

b a

d

e

Fig. 81

a

10 Make a small mix of plaster. First moistening the seam, paint plaster into the V between the two sections and partially fill.
11 Dip lengths of scrim or burlap in plaster and place over the join, dabbing them firmly into position.
12 Replace the next cap and repeat the process until all the caps are in place and all the sections joined.

Chipping out
13 Tip the mould back to the vertical.
14 Remove the cradle.
15 Fix supports from halfway up the mould to the floor, so that the weight of the mould does not put undue strain on the legs.
16 Chip out the figure, beginning at the top and working down.
17 Make good any faults.

Further notes—squeezing It will be noted in the previous section that the seams in arms and legs may be difficult to get at with a brush and with scrim or burlap.

Sometimes the last section of a cast cannot be got at at all from the inside.

In these cases the piece is Squeezed:

(a) When filling this section of the mould, make the bevel on the edge of the cast less steep than previously described (Fig. 81).

(b) Bevel the edge of the mould. Do not bevel away the keys (Fig. 81).

(c) Thoroughly moisten the edges to be squeezed.

(d) Put a thick line of plaster that is beginning to firm up along both the edges to be squeezed (Fig. 81).

(e) Press the two sections of the mould together strongly so that surplus plaster squeezes out of the join (Fig. 81).

(f) Wire or scrim them in position.

Always use the brushing and scrimming method if possible. Small hollow casts may be joined by wiring up the sections, sealing the seam on the outside, pouring plaster into the cast, and rolling it round so that the seam is filled.

Light moulds

Small sculptures with delicate elements are best cast with a light mould which decreases the danger of damage during chipping out.

More complex moulds

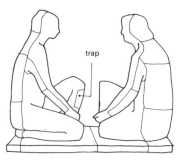

Fig. 82 Large mould showing caps and traps

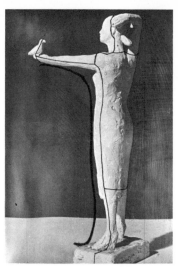

Fig. 83 Figure with outstretched arm
a. Main mould includes part of arm,
b. reinforcement supports arm,
c. when chipping out leave reinforcement in place as long as possible

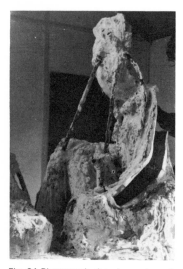

Fig. 84 Photograph showing main part of mould in Fig. 83

Fig. 85 Sculpture modelled on board
a. First half cast, b. sculpture inverted preparatory to casting second half

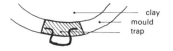

Fig. 86 Trap
An isolated cap. Sides tapered and wire loop incorporated to facilitate its removal from the mould. It allows access for removal of clay and filling

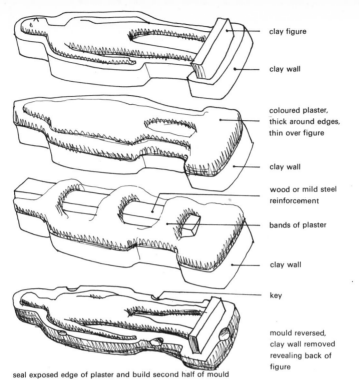

clay figure

clay wall

coloured plaster, thick around edges, thin over figure

clay wall

wood or mild steel reinforcement

bands of plaster

clay wall

key

mould reversed, clay wall removed revealing back of figure

seal exposed edge of plaster and build second half of mould

Casting a small relief

Fig. 87 4 drawings showing the making of a light mould

This is usually simpler than casting a figure.

1 If possible, lay the relief horizontal.
2 Apply a coloured coat all over.
3 Reinforce with wood or mild steel. (A relief will tend to warp, because it is flat.)
4 Add the supporting coat.
5 Remove clay, wash, seal.
6 Apply first coat and back up with scrim or burlap. If shallow, finish off level. Incorporate wire loops for hanging. See Reliefs p. 61.
7 Chip out and finish.

Casting a large relief

1 If possible, lay the relief horizontal. If this is impossible, ensure that the weight of the plaster mould will not drag the

clay away from the modelling board. The mould may need supporting with battens or wood strips from the floor as it develops.

2 Divide the sculpture with shim into suitable sections. Build traps (see Fig. 82, p. 82) for high sections that will not be readily accessible from the back or that make removal of the mould difficult.

3 Build the mould with suitable reinforcement.

4 Make a timber cradle and apply it to the mould, building up the mould so that each section will have a place when the mould is dismantled. Remove the cradle and lay it aside.

5 Dismantle with care. If the mould comes away with the clay still inside it, it will be heavy and could be dangerous.

Lay each section on its appropriate place in the cradle.

6 Clean and seal the mould and fill with plaster and scrim.

7 Apply suitable mild steel and/or wood reinforcement.

Incorporate loops for hanging.

Separators and sealers

The method described so far for treating a mould is either to make a lather with liquid detergent, soft soap or soap flakes or use a clay wash.

If the mould has dried out, it may be best to seal it completely. This is done with shellac, which may be bought already made up or may be made up by dissolving shellac flakes in methylated spirits (denatured alcohol). It should be used quite thin, otherwise it will blur the impression of the modelling. Paint on a coat and permit to dry, then another, until the surface becomes shiny. (Do not paint a very wet mould, as the shellac may come off on the cast.) Paint the shellac surface lightly with thin engine oil or liquid wax.

An excellent separator can be made by dissolving styrrhic acid wax and a little paraffin wax in paraffin (kerosene) over a gentle heat. As the mix cools, stir it until a creamy wax results. It should be stored in a covered jar, otherwise the paraffin (kerosene) will evaporate.

This separator may even be used by itself on plaster, although it tends to go on rather thick unless the surface is sealed first.

It may also be used as a separator for taking casts from wood and stone. It will not damage the originals if used with care. The wax will dry eventually and brush off.

Casting in concrete

Of the many media for casting sculptures, concrete is one of the cheapest and simplest. It can be enormously strong and is suitable for both indoor and outdoor sculptures.

For the purpose of this book, the term Concrete is used to describe any mix that consists of cement, an inert filling material and water. In the building trade, the term has a more limited connotation. The types of cement used for casting are:

Portland Cement is the kind that is normally used in building work. It is cheap and quite satisfactory for straightforward casts. Its disadvantages are its long setting and curing time and its uninteresting colour— although colourants may be added.

High Alumina Cement. The advantage of this cement is that the setting time is greatly reduced. It is usually dark grey-green in colour, but can also be obtained in white and there are a number of brands on the market.

Materials and equipment as for plaster casting.
Also:

 measure, e.g. cup, bowl for measuring dry materials.
 plastic bowl or bath for dry-mixing and wet-mixing.
 alumina cement.
 aggregate (see The Mix below).
 fibreglass chopped strand mat.
 reinforcement: mild steel.

The Mix The following are typical mixes:

Group one **1** 1 part *cement* to 3 parts *sharp sand.*

 2 1 part *cement* to 3 parts *silver* or *soft sand.*

 3 1 part *cement* to 1 part *marble dust* + 3 parts *marble chips.*

Group two **4** 1 part *cement* to 1 part *powdered pumice* or *water-ground flint.*

Preparing the mix

Use an accurate measure, e.g. cup, can, basin, which can be levelled off. Mix the dry materials thoroughly and then slowly add water, mixing all the time until the mix is of a 'sandcastle' consistency (i.e. when a handful is squeezed it holds together).

Preparing the mould

A plaster waste mould is used. It must be sufficiently strong to stand fairly hard usage. If necessary, it should be reinforced with wood or metal. It should have as fine a seam as possible and

any Feather, or inward-projecting ridge of plaster caused by the shim, should be removed.

It is usual to fill the sections of a mould separately and join afterwards. Simple moulds (e.g. a head) may be joined first if there is adequate access to the inside.

There are two ways of preparing the mould:

(a) It may simply be thoroughly soaked with water. The advantage of this method is that it is simple and efficient, especially if the casting is done immediately after removal of the clay.

(b) Seal the surface with shellac and wax (liquid furniture wax is suitable). If the mould has dried out, resoaking it is not always satisfactory and sealing will probably give better results. Care must be taken that bubbles of air do not cling to the surface of the mould when filling.

Filling the mould

It is assumed that a high alumina cement is used, which shortens the setting time.

Using mixes of group I:

1 Prepare the mould. If it has been soaked, ensure that it is thoroughly wet, but that it has no water lying on the surface.

2 Take some neat cement (if mix 3, then 1 part cement to 1 part marble dust) and mix it with water to the consistency of double (heavy) cream. This is called Goo. Paint it on to the inside of the mould, covering the part that is horizontal or near-horizontal to a thickness of up to $\frac{1}{4}''$. The concrete will not stick properly to vertical or overhanging parts of the mould (Fig. 88).

3 Lay in concrete to a depth of 1″ or $1\frac{1}{2}''$. With a rounded piece of wood (a mallet or the handle of a chisel) tamp the concrete firmly until it is quite hard. It will decrease in thickness to about $\frac{3}{4}''$ (Fig. 89).

4 The edges, where the concrete reaches the top of the mould, should be bevelled (see also p. 80) so that, when the two parts of the mould are joined, a V-shaped gap will be left.

5 Let the concrete harden for about three hours and then tip the mould so that a part that has not been filled is horizontal, and repeat the process.

Continue until each part of the mould is lined with a layer of concrete about $\frac{3}{4}''$ thick, well compacted and bevelled round the edge (i.e. the edges slope inwards).

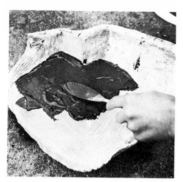

Fig. 88 Lay in goo

Fig. 89 Lay in and tamp concrete

Fig. 90 Horizontal parts of mould filled, edge bevelled

Using mixes of group II: In this case, the first layer consists of the concrete itself.

1 Apply a layer $\frac{1}{4}''$ thick to the mould.

2 Lay in a layer of fibreglass chopped strand mat (Fig. 92). (The mat as delivered may usually be divided into two thinner layers.) Dab it into the concrete by stippling with a stiff brush (Fig. 93, p. 89).

3 Apply a second $\frac{1}{4}''$ layer of concrete.

4 Apply a second layer of fibreglass.

5 Apply a further layer of concrete and trowel down (Fig. 94).

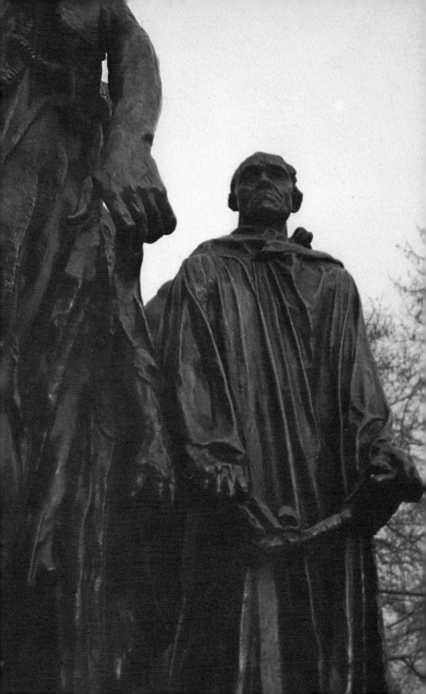

Fig. 92 Lay in fibreglass

Fig. 93 Stipple

Fig. 94 Next layer trowelled

Fig. 95 Inaccessible seam squeezed

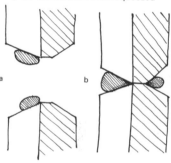

a

b

sqeezing

A bigger cast will require more layers; a small cast can be made thinner.

Trim the edges so that a good bevel is achieved as in 4, p.86.

Reinforcing

Slender elements, such as legs, will need reinforcing with metal, as will large sculptures, particularly of group I. (See Reinforcing Plaster pp. 76, 77 for layout of reinforcing.)

Use mild steel bar for reinforcing unless the sculpture is very small (in which case galvanised wire can be used). Steel should

Fig. 91 *Burghers of Calais*, detail, by Auguste Rodin, bronze

not be treated before use, but grease should be removed and loose rust wire-brushed off.

Bend the iron carefully to take the shape of the inside of the cast at the place you wish to reinforce, lay the iron on and cover with at least half an inch of concrete or with concrete and fibreglass. This is usually done before the mould is joined up. Thin load-bearing sections, such as legs are better reinforced with three thin irons than with one thick one.

Joining the mould
The process is similar to that used when filling with plaster. If the seams are accessible from the inside, they will be packed. If the seams are inaccessible, they will be squeezed.

If the seam is accessible
1 Clean edges of the mould and free them from particles of sand.
2 Put the cap in position and wire or scrim it in place.
3 If the mould is soaked, moisten the edges thoroughly.
4 Paint a thin layer of goo in the V-shaped gap round the join.
5 Pack the gap with concrete and tamp well down.

If the seam is inaccessible
1 Trim the edge of the mould so that only a narrow edge is left. The bevel on the concrete should be less than for packing.
2 Wet the concrete and the mould if it has been soaked.
3 Place a ridge of goo along the concrete edge in both the main mould and the cap.
4 Press the cap on to the mould and work it into place so that goo squeezes out on either side of the join. Wire and scrim in place (see p. 81 plaster casting).

Curing
Concrete must be kept wet until it is thoroughly cured.
(a) Keep any part of the mould that has been filled and is awaiting joining covered with damp rags or sacks and plastic sheet.
(b) When the sections have been joined, stuff the inside with wet sacks or paper if possible.
(c) Concretes of group 4 will require spraying at intervals during the curing process until they will absorb no more water.
(d) If the mould has been soaked spray it at intervals.
(e) Cover the whole mould and the cast with plastic sheet for several days. The slower and damper the cure, the better will be the concrete.

Chipping out

This is done as with a plaster cast. It is easier, because there is less danger of chipping the concrete cast than with one of plaster. It is not necessary to have a coloured first coat in the mould as it is easy to see when one arrives at the concrete.

Use of fibreglass

(a) By using mixes of group II with fibreglass, very light casts can be made, especially if used with a pumice aggregate. This is particularly useful for small sculptures for indoors and for reliefs where the wall on which a relief is suspended would not bear the weight of a heavy sculpture. Despite the fibreglass, the sculpture will not be very strong, and if at all large, especially if a relief, mild steel reinforcing may be desirable.

(b) Fibreglass may be used with mixes of group I if the particles of aggregate are not too big. It will permit a thinner cast to be made.

Mending faults

If possible, mend faults as soon as the sculpture is out of the mould. Make a small mix of goo and mix with it a little P.V.A. (polyvinyl acetate) or acrylic emulsion. Thoroughly moisten the faulty part, paint with a thin solution of P.V.A. and water and fill. Keep damp for at least twenty-four hours. The patch may be darker than the surrounding concrete, especially if the system of soaking the mould is used. In this case, when the patch has firmed up after about three hours, a dab of plaster may be put over it. Keep damp as long as possible (see following paragraph).

Bloom

When a concrete sculpture is cast by the soaked mould method, the cement has the effect of destroying the surface of the mould. This leaves a whitish bloom on the sculpture. Once it is thoroughly cured, the bloom can be brushed off with a stiff bristle brush. However, it may be felt that the bloom adds quality to the appearance of the sculpture and that it is better to leave it either completely or in places.

Drainage

If a hollow concrete sculpture is to be out of doors, leave a drainage hole at the bottom: otherwise, if a fault appears, it may fill up with water. A sculpture which is to be placed out of doors should be designed in such a way that pools of water, which could freeze and cause damage, do not collect.

Casting in polyester resin and fibreglass

This versatile medium is widely used nowadays. The manufacture of car-bodies, boats, fish-ponds, sinks and wash-basins are some of its applications. Pigment and various fillers, including metal powders such as aluminium and bronze, can be added to it to give a desired surface. It weathers well, is extremely light, and the colour and finish are integral parts of the cast.

Because of these qualilities and the ease with which it is cast, it is widely used in sculpture today.

In principle it consists of a transparent liquid resin which sets hard when a suitable catalyst (hardener) is added. An accelerator adjusts the length of the hardening process. As it is rather brittle, the resin must be reinforced with fibreglass. It must be used on a rigid form and for sculpture this is usually a plaster waste mould, which must be coated with a suitable separator when quite dry.

Materials and equipment
Brushes: 1"-1½" paint-brush (for gel coat).
circular stiff bristled for stippling resin into fibreglass.
Roller: a finned roller may be bought. Split washer-rollers may be made up (for large surfaces).
Palette knife, for mixing pigments and fillers with resin.
Measure: cup, can, etc.
Plastic bowl, for prepared resin.
Fibreglass chopped strand mat.
Polyester resin.
Thixotropic paste (this makes the resin pasty and stops it running down steep surfaces; sometimes ready-mixed with the resin).
Accelerator (sometimes ready-mixed with the resin).
Catalyst (or hardener).
Wax emulsion, parting agent for plaster.
Cellulose thinners, for rinsing brushes.
Detergent, for washing out brushes.
Fillers: pigment, powdered metal or other.
The suppliers will give information regarding proportions of various elements in a mix.

Conditions will cause variations. For example both low temperature and the addition of fillers will increase the curing or gelling (going-off) time and will demand a larger proportion of hardener and perhaps accelerator.

The mould

A normal plaster waste mould may be used. It should be thoroughly dry, as dampness slows or prevents gelling (going off).

It is filled as for plaster and concrete; i.e. if small and the interior is accessible, the mould may be joined first and then filled; if large or the inside is inaccessible, the sections are filled first and then joined.

Wax emulsion may be painted direct on the dry plaster surface to seal the mould.

Fig. 96 Gel coat, with black pigment, laid in

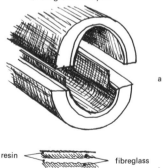

Fig. 97 Fibreglass supporting layer, rolled in with finned roller

Fig. 98 Reinforcing ridge stippled in (D-section paper used to support fibreglass before it gels)

Fig. 99 a. Lapping and joining fibreglass,
b. diagram of layers

resin
fibreglass
gel coat
plaster
a
b

Casting

The first coat next to the plaster is called the gel coat. It consists of resin, hardener, and accelerator plus any desired filler. This may be powdered metal or any inactive powdered material (pumice, sawdust, powdered slate, etc.) or pigment, usually obtained in paste form.

If the sculpture is not flat, thixotropic paste may be added. Sometimes the resin is bought with thixotropics added. Manufacturers usually advise that thixotropics should not be added to the gel coat if a metal filler is used. These fillers have the effect of making the resin somewhat thixotropic.

The series of supporting coats consist of fibreglass impregnated with resin and hardener and applied to the back of the gel coat. The method is either to paint a thin layer of resin over the gel coat, apply the fibreglass and stipple with a stiff brush or roll until no air bubbles remain, or to paint resin on a sheet of brown paper, place the fibreglass on it and roll it until it is impregnated, then stipple or roll in place. The multiple layers of resin and fibreglass form a laminate.

Reinforcing

Ridges in the fibreglass make an excellent stiffening. Rope laid over the inner surface, and fibreglass and resin carried over it give a D-sectioned ridge, or D-section paper may be bought and used instead of rope (Fig. 98).

Large sculptures or sculptures liable to strain from wind and weather may require metal reinforcement. This may be done as described for plaster. Carry resin and fibreglass over the irons and ensure that no part of the iron is left unpainted with resin.

Chipping out

Resin shrinks very slightly and can be lifted out of a mould that has no undercuts (i.e. parts which cause the mould and the cast to lock together). Otherwise, chip out carefully as for plaster.

Method, using a plaster waste mould

Always obey manufacturers' instructions.
1 Ensure that the mould is thoroughly dry and then seal with the parting agent.
2 Mix a batch of resin, accelerator and filler, preferably enough

for the whole gel coat.

3 Take as much as you need for one operation and add hardener.

4 Paint the gel coat on the inside of the mould. Do not damage the wax emulsion sealer. Rinse out the brush with thinners immediately. Do not let resin set in the brush (Fig. 96).

5 Lay in the supporting coat of resin and fibreglass. This is probably three layers at the most, two being sufficient for small sculptures. Make clean, slightly bevelled edges. Thicken up at the edge and either double the fibreglass back or snip away surplus.
Keep edges of the mould clean (Figs 97, 99).

6 Join the sections of the mould and fill the seams, first with a layer of gel coat, then with resin and fibreglass.

7 Chip out.

8 Repair any faults with gel-coat mix.

Notes A warm, draught-free atmosphere is best for resin. Cold increases setting time or even prevents it; draughts cause unequal setting and consequent warping.

Hard resin will break off a plastic bowl.

Brushes should be rinsed in cellulose thinners immediately after use.

Brushes should be washed in a strong solution of detergent after a session.

Do not allow moisture to come into contact with the resin. It will upset the setting. Even a wet brush can have this effect.

A section that cannot be got at from inside may be squeezed. Rollers with long wire handles may be improvised for narrow spaces. In this case, fix a lapping piece of fibreglass on the mould, replace the cap and roll the fibreglass down (Fig. 99).

Try and avoid puddles of resin forming in hollows.

Use a thixotropic resin on steep parts; otherwise fill horizontal parts of the mould only.

Remember that fibreglass is glass: handle with care (preferably with gloves). Avoid getting liquid resin on your skin.

Further uses

Resin is so versatile that it may be incorporated in sculpture in a variety of ways.

Objects such as pieces of wood, metal, etc. may be laid on a surface and resin, either clear or pigmented, flooded round them. The cast surface may be sanded down.

Channels may be cut in plaster, chipboard (wood-waste building board), etc. and filled with pigmented resin.

A variety of surfaces, coarse or smooth, can be used either by incorporating various materials as fillers or by covering the casting surface with a thin layer of for instance sand, to be picked up by the resin.

Pigmented resin may be dribbled on to a surface.

There is much room for experiment and invention. Test new ideas before committing yourself, because some fillers affect the setting of the resin.

Working direct

Polyester resin is not one of the pleasantest mediums to handle but it can be used direct over an armature. This can be made quite light, as the resin, when reinforced with fibreglass, is very strong.

(a) Build the armature or core. (If of expanded polystyrene or other plastic foam, then seal well; expanded polyurethane is not affected by polyester resin.)

(b) Mix the resin with 15% thixotropic paste and apply with scrim, burlap, or butter muslin. Reinforce with fibreglass chopped strand mat or, if a finer reinforcement is needed, woven fibreglass.

(c) Fillers may be added: pigment or powered metal gives a desired finish, vermiculite granules will bulk out the resin.

(d) The surface may be worked with Surform, files, etc.

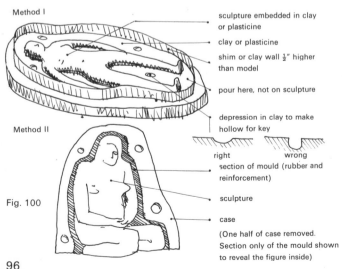

Method I

sculpture embedded in clay or plasticine

clay or plasticine

shim or clay wall $\frac{1}{2}$" higher than model

pour here, not on sculpture

depression in clay to make hollow for key

Method II

right wrong

section of mould (rubber and reinforcement)

Fig. 100

sculpture

case

(One half of case removed. Section only of the mould shown to reveal the figure inside)

Silicone rubber, latex and polyvinyl moulds

Rubber and synthetics are very useful for casting sculptures. A flexible mould is produced which peels off the master, and from it may be made many reproductions. Large flexible moulds will require a plaster case to support them. Costs are much greater than with plaster casting, but the process is often simpler and very much more so when a number of casts are required.

Silicone rubber

Silicone rubber for casting sculpture may be obtained in varying grades of viscosity (fluidity). Generally speaking, the more fluid, the less strong. Larger moulds will usually require a less fluid grade. Reinforcing materials can be incorporated. The rubber remains liquid until a catalyst is added, when an irreversible chemical process starts and the rubber begins to gel. A curing period is necessary.

This material has quite a long shelf life if stored under cool conditions. When buying these moulding materials, always obtain manufacturers' instructions, read them carefully, and follow them.

These notes may need amending to accord with the instructions of a particular manufacturer or supplier.

Mixing Different grades of the same chemical compound may be mixed. They should be thoroughly stirred.

Catalyst must be added in the correct proportion and mixed thoroughly.

The master Moulds can be made from masters (originals) of most materials: clay, plaster, resin, wood, metal, etc.

Separators A solution of liquid detergent, wax or polyethylene spray. Rarely needed when making a cast.

Casting: method I, suitable for small figures (Fig. 100)

1 Half embed the figure in clay or plasticine. Make hollows for keys so that the two halves can be filled together.

2 Build wall of shim or clay etc. round figure and $\frac{1}{2}''$ higher so that the figure sits in a kind of box or bowl.

3 Paint the whole with detergent solution and allow to dry.

4 Prepare a mix of silicone rubber and catalyst.

5 Pour so that the mix rises round and covers the figure—do not pour directly on to it.

6 Allow to cure (approximately six hours).

7 Remove rubber and figure together from clay, clean up, reverse, replace wall.

8 Paint again with detergent and pour second half.

9 Allow to cure, separate and remove the figure.

10 Cut hole for pouring casting material.

11 Fill.

Method II: skin mould, suitable for medium or large figures (Fig. 100)

1 Apply release agent (separator) to the figure.

2 Paint a layer of rubber over the figure.

3 When gelled, press on a layer of butter muslin (thin muslin), open weave fibreglass, or a similar open weave fabric as reinforcement.

4 Apply a further coat of rubber, containing a higher percentage of catalyst, so that both coats set at the same time, and repeat coats until sufficiently thick. Allow to cure.

5 Build a case of Plaster of Paris over the mould, in two parts, more if necessary, for ease of removal.

6 Remove flexible mould from plaster case and sculpture from mould. If necessary the mould may be slit to facilitate removal of figure. Take care that the edges of the slit are replaced accurately when filling.

7 Replace mould in case and fill as desired.

Fig. 101 Section of mould showing how rubber mould is tied into plaster case

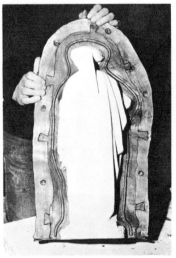

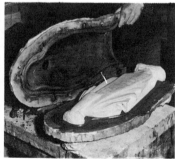

Fig. 102 Rubber mould open to show cast figure

Method III
1 Half embed the sculpture in clay or plasticine.
Lay over the exposed part a sheet of paper or plastic sheet to protect the sculpture (Fig. 103, p. 100).
2 Make an even blanket of clay over the sculpture the thickness of the proposed mould (Fig. 104).
3 Make pouring hole and air vents and build funnel (Fig. 105).
4 Build a plaster case over the clay (Figs. 106-7).
5 Turn over and remove the clay or plasticine described in 1.
6 Make a blanket of clay over the exposed half of the sculpture as in 2.
7 Make keys in the exposed edge of the case and seal.
8 Make second half of case.
9 Remove second half of case, remove clay blanket, clean up sculpture.
10 Make groove in clay for key.
11 Apply parting agent.
12 Pour rubber through funnel into the space created by removal of clay blanket in stage 9.
13 Allow to cure, reverse, remove clay from first half of case and make other half of mould.
14 Fill.

Polyvinyl moulds

This material is used hot and has a melting point of 120°-130°C. It is poured at 120°C. The main advantage is that it can be re-used indefinitely so long as it is treated with care.

When bought, it is in its set (hard) state. It may be obtained in different grades of hardness.

Melting Cut up into small pieces. Small quantities may be melted in a saucepan heated over an electric hotplate or an asbestos mat over a gas ring. It must be stirred frequently, otherwise it will burn and its quality will deteriorate.

For larger quantities, a double pan (double boiler) with an air space between should be used. This can be made by cutting a hole in the lid of a pan or can and inserting a smaller lidded can into it. A twist of thick galvanised wire will keep the inner can from slipping down (Fig. 111). Special melting pots may be bought.

Add the polyvinyl in small quantities and stir frequently.

The master Any material that will withstand the heat may be cast, although porous materials must be sealed adequately,

Fig. 103 Figure embedded in clay

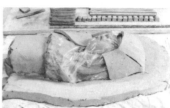

Fig. 104 Clay blanket

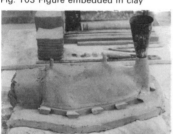

Fig. 105 Funnel and airvents added, also ties for fixing to plaster

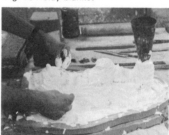

Fig. 106 Plaster case

Fig. 107 Plaster case finished

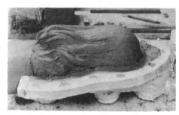

Fig. 108 Case reversed exposing back of head

Fig. 109 Case completed

Fig. 110 Clay blanket removed from top half and rubber poured

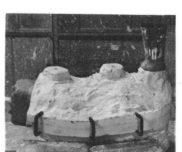

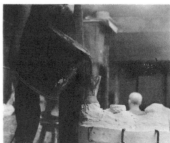

otherwise air bubbles will be given off which will spoil the mould; seal with three thin coats of shellac, three thin coats of aluminium paint, and a final thin coat of shellac.

Plaster may be sealed this way, but best results are obtained by soaking thoroughly in water.

Plasticine can be cast so long as the polyvinyl is as cold as possible and not poured directly on to the model. A coat of shellac will protect thin parts.

Wet clay may be cast with no preparations, and also metal.

Casting, small objects

1 Seal if necessary and fix to the base, board, or table.
2 Make a wall round of oiled paper, metal foil etc. (a food can may be used and, after casting, the bottom cut out and the mould removed). The sculpture rests within this enclosure.
3 Melt polyvinyl, allow temperature to drop to 120°C and pour around, but not directly on to the model (Fig. 111).
4 Allow several hours to set.
5 Remove wall and extract model.
One side of the mould may be slit if necessary. Before filling apply french chalk (white chalk) to the sides of the slit to ensure they marry correctly. In this case, tie with string or elastic band before filling.
For larger objects, Methods I and III (pp. 97–8) may be used.

As wet clay can be cast, a clay wall may be built round the complicated part of a sculpture, that part moulded in polyvinyl and a plaster mould made over the whole.
Moulds that are finished with may be stored indefinitely and cut up to melt and re-use.
Only approximately half a dozen polyester resin casts may be taken from a polyvinyl mould before the mould needs to be remade. A large number may be taken from a silicone rubber mould.

Latex

This moulding material is little used by sculptors in England although in the United States it is used quite commonly.

It consists of a liquid rubber to which, usually, a hardener must be added to start the gelling process. The percentage of hardener determines the gelling period. It is in many ways similar

Fig. 111 Pouring polyvinyl. Improvised double container for melting polyvinyl

to silicone rubber and the methods of use are the same although manufacturers' instructions must be read and carefully observed.

Developments are taking place quite rapidly in the use of flexible moulding materials and comparisons may very soon be out of date. Buy what is most readily available and where there is a choice, use that which experience shows to give the best results.

For further reading

Clay
Ceramic Sculpture by Beth Davenport Ford. Reinhold, New York 1965.
Creative Clay Craft by Ernst Röttger. Batsford, London 1962 and Reinhold, New York.
Modelling and Sculpture by Edouard Lanteri (three volumes). Dover, New York.
Pottery by Murray Fieldhouse. Foyles, London.
Simple Pottery by Kenneth Drake. Studio Vista, London 1965 and Watson-Guptill, New York.

Casting
The Technique of Casting for Sculpture by John W. Mills. Batsford, London 1967 and Reinhold, New York.

Resin and Fibreglass
Fibreglass for Amateurs by C. M. Lewis and R. H. Waring. Modern Aeronautical Press Ltd, Hemel Hempstead, Hertfordshire.

Resin, polyvinyls and vinyl modelling compounds
New Materials in Sculpture by H. M. Percy. Alec Tiranti Ltd, London 1962 and Transatlantic, New York.
Plastics as an Art Form by Thelma R. Newman. Chilton, Philadelphia and New York.

Concrete
Sculpture in Ciment Fondu by John W. Mills. London Contractors Record Ltd, London 1959.

General
Art and Visual Perception by Rudolph Arnheim. Faber and Faber, London 1954 and University of California Press, Berkeley, California.
Contemporary Sculpture Techniques by John Baldwin. Reinhold, New York.
Human Anatomy for Art Students by S. Tresilian and H. J. Williams. Chapman and Hall, London 1961.
Methods and Materials in Sculpture by J. C. Rich. Oxford University Press, London and New York.
The Nature of Design by David Pye. Studio Vista, London 1964 and Reinhold, New York.
The Necessity of Art by Ernst Fischer. Penguin Books, London and New York 1963.
Sculpture in Plastics by Nicholas Roukes. Watson-Guptill, New York.
The Sculptors Manual edited by Geoffrey Clarke and Stroud Cornock. Studio Vista, London.

List of suppliers

For Great Britain **A** = artists' materials suppliers **B** = builders' merchants **H** = hardware stores **T** = Alec Tiranti Ltd, 72 Charlotte Street, London W1 (who will supply large and small quantities).
For America **B** (US) = building materials suppliers **H** (US) = hardware stores **P** (US) = plastics suppliers **A** (US) = art materials suppliers; two firms which specialise in mail orders and will send catalogues on request are:
Arthur Brown and Brothers, 2 West 46 Street, New York
Sculpture House, 38 East 30 Street, New York.

Aluminium wire **T**: **A** (US).
Armature support **A**, **T** (adjustable and fixed): **A** (US).
Burlap fabric or department stores (US).
Callipers **A**, **T**: **A** (US), **H** (US).
Cellulose thinners **H**, **T**, motor suppliers: **H** (US) and paint stores.
Cement **B**, **T** (High Alumina Cements, eg Ciment Fondu): **A** (US), **B** (US).
Chicken wire **H**: **B** (US), **H** (US).
Clay **A**, **T**, also Fulham Potteries, 210 New Kings Road, London SW6 and Potclays Ltd, Wharf House, Copeland Street, Stoke-on-Trent: **A** (US), also Stewart Industries, 6520 N. Hoyne Avenue, Chicago, Illinois.
Composition lead piping **T**.
Expanded polystyrene Sheffield Insulating Co., Hillboroughs Works, Langsett Road, Sheffield 6, and South and Western Insulation Co. Ltd, Pen Mill Trading Estate, Slough, Buckinghamshire.
Fibreglass and polyester resin **T**, also Baynes Butler Plastics Ltd, Ringwood, Hampshire, and West Pole Motors Ltd, Trent House, 89 Bramley Road, London N14: **P** (US).

Fillers see *fibreglass*: **P** (US), also Metals Disintegrating Corporation, PO Box 290, Elizabeth, New Jersey.

Finned rollers see *fibreglass*: **P** (US).

Galvanised wire **H**: **B** (US), **H** (US).

Grog clay suppliers: **A** (US), also Stewart Industries, 6520 N. Hoyne Avenue, Chicago, Illinois.

Latex Bellman Ivey and Carter Ltd, 358A Grand Drive, London SW20: **A** (US) and other flexible moulding materials.

Liquid soap drug stores (US).

Marble dust and chips Edgar Udny and Co., 83 Bondway, London SW8: Cande Sand Supplies Corporation, 9029 Faragut Road, Brooklyn, New York, or check the yellow pages of your local telephone directory under *Marble Dust*.

Mild steel rod **B**, **T**: **B** (US) and welding suppliers.

Modelling stands **T**: **A** (US).

Modelling tools **A**, **T**: **A** (US).

Modelling wax **A**, **T**: **A** (US).

Paraffin wax **H**, **T**: **A** (US), **H** (US).

Plasticine **A**, **T**: **A** (US).

Plaster **A**, **B**, **T**, also British Gypsum Ltd, Ferguson House, Marylebone Road, London NW1, and Terrey Brothers, 58 Andalus Road, London SW9: **A** (US), **B** (US), **H** (US) and paint stores.

Plastone **A**, **T**.

Polyester resin see *fibreglass*.

Polyester resin pigments see *fibreglass*.

Polyvinyl casting compound (Vinamould) **T**, also Vinatex, Devonshire Road, Carshalton, Surrey.

Powdered metals **T**: Metals Disintegrating Corporation, PO Box 290, Elizabeth, New Jersey.

Powdered pumice **H**, plaster suppliers: **H** (US).

Powdered stone masons' yards: **B** (US) and stone masons.

Powdered waterground flint Potclays Ltd, Wharf House, Copeland Street, Stoke-on-Trent.

P V A **H**, **T** (Unibond, Polybond).

Pyruma **H**.

Rubber moulding materials see *Latex*.

Sand, sharp and soft **B**: **B** (US).

Scrim **T**, also Dura Fabrics Ltd, 43 Bartholemew Close, London EC1.

Shellac **H**, **T**: **A** (US), **B** (US), **H** (US).

Shim **T**, toolshops: **A** (US), **H** (US).

Silicone rubber (Silastomer) **T**, also Midland Silicones Ltd, Reading Bridge House, Reading.

Soft soap **T**, chemists.

Spatulas **T**, toolshops: **A** (US), **H** (US).

Styrrhic acid wax **T**, chemists.

Vinyl modelling compound **T**.

Wax emulsion see *fibreglass*.

White glue (US) **A** (US), **B** (US), **H** (US) – Elmer's Sobo, etc.